Nikon
F-501

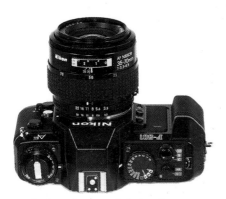

Michael Huber

HOVE ~ FOUNTAIN BOOKS

In U.S.A. and Canada

the Nikon F-501 is known as the

NIKON N2020

All text, illustrations and data apply to cameras with either name
U.S. Edition ISBN 0-86343-089-9

NIKON F-501

First English Edition July 1987
English Translation from the original German
by Liselotte Sperl
Edited by George Wakefield
Series Editor Dennis Laney
Typeset by Direct Image Photosetting, Hove
Reprinted in Great Britain by
Macdermott & Chant Ltd
1989
ISBN 0-86343-064-3

Published by
HOVE FOUNTAIN BOOKS

45 The Broadway
Tolworth
Surrey KT6 7DW

34 Church Road
Hove
Sussex BN3 2GJ

U.K. Trade Distribution by
Fountain Press Ltd
address
as above

U.S.A. Distributor
Seven Hills Books
49 Central Avenue, Suite 300
Cincinnati, Ohio 45202

Contents

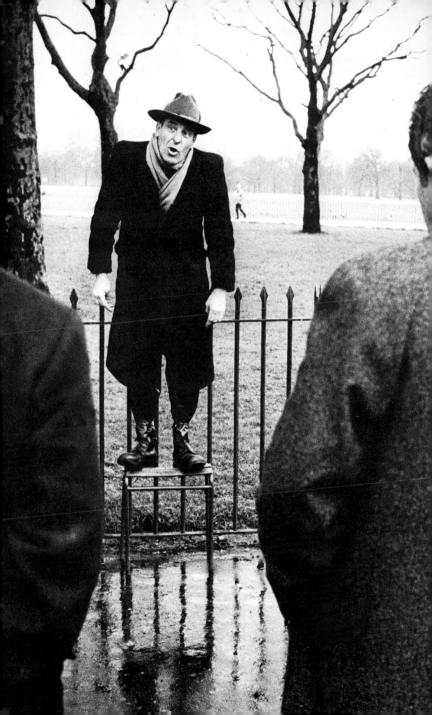

Nikon Upgrades

Nippon Kogaku, better known as Nikon, is still the world number one in professional SLR photography. Old F2 cameras are still being traded at the highest prices amongst photojournalists, and those who had the chance to acquaint themselves fully with the all electronic F3 were usually delighted. Other models, such as the FM, FM-2, FE, FG and FA, have an enthusiastic following amongst amateur photographers. When competitors flooded the market with a wave of multi-program cameras, where the camera with all the LC displays and touch-sensitive keys was often indistinguishable from a mini computer, one had to resist the impression that Nikon's R & D engineers had over-reacted with an attitude of staunch conservatism and missed all this technical progress.

Nikon's reply came in 1985 with the launching of the F-301. The F-301, the sister model of the F-501, is a camera with fully integrated motor and computerized interior. It can be operated like a conventional camera, although it avails itself of the latest technical developments. The novice or inexperienced photographer finds it easy to use the camera, whilst the more professional user is able to utilise its technical sophistication to the full.

Then Minolta surprised the market with the introduction of their unique autofocus SLR system. Their system incorporated the entire focusing facility and the motor in the camera. Consequently the lenses were light and handy, the focusing fast and precise. However, one severe drawback that passed almost unnoticed in the excitement over this new hi-tech camera, was that earlier lenses were incompatible with the new bayonet fitting and could be used only with special adapters. Likewise the older cameras could not be used as a second body for the new lenses. But why should it not be

No snapshot. This scene at Speaker's Corner was taken quite intentionally with a 35mm wide-angle lens. *Photo Rudolf Dietrich*

possible to design a new generation autofocus camera that is compatible with all the existing lenses? Many people did not think it was possible, but NIKON has overcome this obstacle. The new Nikon F-501 autofocus SLR camera is able to utilize the old bayonet (designed in 1959) for the new AF lenses. This means a further victory for Nikon – after all, it was Nikon who managed to adapt the good old bayonet for the modern program modes!

What this means in practice is that you need not throw away your old Nikon equipment if you buy a new F-501 camera. The old lenses can be used with the new autofocus F-501. You cannot expect autofocus facility with the old lenses, but they will work perfectly with manual focusing. If it happens to be a fast lens, then the electronic focusing indicator may be just the job. Moreover some of the old Nikon lenses can be used with complete automatic focusing by means of the special autofocus converter.

I was a convinced sceptic about auto focusing, but the quality of the Nikon autofocus system convinced even me. It cannot be compared with the previously-known systems used in snapshot cameras. Because of two different AF shooting modes and the additional focusing memory lock, the F-501 offers unrestricted image creation with fully automatic focusing. The following chapters will demonstrate how, by making use of its many technical facilities, you can use your F-501 in many different ways ranging from a fast snapshot camera to an instrument for precise and selective manual focusing and exposure. You should be able to create exactly the right pictures that you had always imagined. Have fun!

Operating Elements

A successful photographer has to be able to handle his camera automatically. We shall therefore start by looking at the operating elements in some detail.

Looking at the camera from the top with lens pointing forward, we see on the right, the shutter release button with integrated film advance mode selector. (L = lock, i.e. shutter release is locked, power is turned off; S = single-frame shooting; C = continuous shooting). The shutter release button has four operating modes: to activate exposure meter, to activate autofocus function, to release the shutter, and as the switch for automatic film transport. Depressing the release button lightly to fingerguard level will activate not only the exposure meter, which is indicated by illumination of the shutter speed scale in the viewfinder, but also the autofocus function. This means the autofocus function takes a distance reading which is used by the autofocus motor to set the distance on the lens. The shutter is released only after the release button is fully depressed. After the exposure has been made, the film is automatically advanced to the next frame.

The frame counter window is at the right of the release button. Behind that is a switch which activates/de-activates the audible warning signal. This bleep tone signals any error in the automatic DX setting, end of film, self-timer running, danger of camera shake and over- or underexposure. Behind and to the left, is the film rewind button and below that is the release catch for the film rewind lever. The film can only be rewound by sliding the release catch to the right and then depressing the rewind button.

To the right of the viewfinder prism is the exposure mode selector dial. The selected positions are locked to prevent accidental change of mode. "P DUAL" indicates dual program auto exposure mode, i.e. the camera will automatically switch between high speed and normal program. "P" is the program for small apertures and longer exposure times. "P HI" favours

Operating elements of the Nikon F-501

1 Self-timer LED
2 Self-timer button
3 Lever for auto-exposure lock
4 Focusing lock
5 Autofocus contacts
6 Lens release button
7 Autofocus coupling
8 Focus mode-selector dial
 M: Focus-assist operation/
 manual focusing
 S: Single servo autofocus
 C: Continuous servo autofocus
9 Battery holder bracket
10 Battery holder for AAA size
 batteries

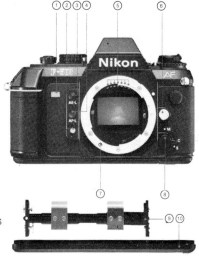

24 Aperture cam
25 Aperture ring
26 Focusing ring
27 Depth of field scale
28 Infrared compensation index
29 Aperture/distance index
30 Distance scale
31 Aperture scale
32 Minimum aperture lock

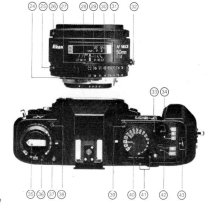

33 Film advance mode selector/
 fingerguard
34 Shutter release button
35 Rewind crank
36 Film speed ring/exposure
 compensation dial
37 Red indicator LED
38 Exposure compensation dial
 lock release button

39 Exposure mode selector
 dial lock release button
40 Exposure mode selector dial
41 Rewind button
42 Audible warning switch
43 Frame counter

12

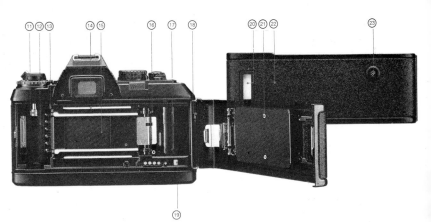

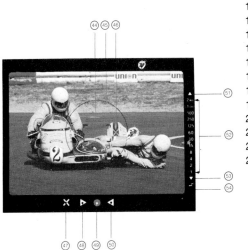

11	Film rewind fork
12	Film compartment
13	DX contacts
14	Viewfinder eyepiece
15	Shutter blind
16	Film transport sprockets
17	Film take-up spool
18	Camera back hinge release
19	Film leader index
20	Film window
21	Film pressure plate
22	Camera back
23	Film advance indicator

44	Focusing area	50	Focus-to-left arrow – for too near subject	
45	Metering area, 12mm dia.	51	Over-exposure warning	
46	Clear matt field	52	Shutter speed indicators	
47	Autofocus impossible indicator	53	Underexposure warning	
48	Focus-to-right arrow – for too distant subject	54	Flash-ready light	
49	In-focus indicator			

faster shutter speeds at the cost of larger apertures. "A" indicates aperture priority mode. The camera will set itself automatically to manual exposure mode (shutter speed and aperture) as soon as a shutter speed is selected on this setting ring. The mode selector dial is unlocked by depressing the small chrome button in front of it, just by the prism housing.

At the top of the viewfinder prism is the accessory shoe with flash contacts. Using a Nikon system flashgun it is possible to shoot in TTL flash mode. If you have the special Nikon AF flash SB-20 it is even possible to obtain automatic focusing in total darkness. Those of you with some engineering background will recognize this by the extra contact in the accessory shoe.

The red LED, to the left of the viewfinder prism, indicates correct film loading and film transport. If this LED blinks continuously, then it indicates either "film transport blocked", or "error in automatic DX", or "film end". If it illuminates for a short time, then this means that film transport is functioning properly. If you look at this LED more closely you will notice a mark indicating the film plane; this is particularly useful for close-ups. At the far left is the film rewind knob with fold-out rewind crank. The rewind knob serves at the same time to lock the back panel. This back panel lock is released by pulling up the rewind knob. The outer ring around the rewind button serves as film speed ring and exposure correction scale. These settings are also lockable. Exposure correction settings are possible between -2 and +2 exposure stops.

Now let's examine the standard 50mm f/1.8 AF lens from the top. At the very front of the lens is the manual distance-setting ring, which even a modern autofocus lens has to have for some critical shooting situations. Behind that is the distance scale window. The bold white marker has several functions, just as with most Nikon lenses. It serves not only as the marker for both the distance scale and the aperture scale, but also as the marker for aligning the lens and camera when changing lenses. To the left and right of this white index marker is the depth of field scale. Further back, near the bayonet, is the aperture scale and aperture readout scale. This second aperture scale,

closer to the camera, is not used with the F-501. It is for use when the lens is mounted on other Nikon cameras where it is used to convey the set aperture value to the viewfinder. A new facility with Nikon lenses is the ability to lock the aperture, which is particularly useful in the program modes if you wish to lock the aperture in the largest possible value, i.e. the smallest possible aperture opening. At the very rear, close to the bayonet, is the black control ring to transfer the aperture values from lens to camera.

If we now view the camera from the front we see at the top left a small red LED: this indicates the self-timer sequence. To the right of this LED is the AE-L (Auto Exposure Lock button). As long as this button is kept depressed, the last metered exposure value will be stored, to be recalled when the release button is depressed. This applies in all automatic modes and operates regardless of any changes in lighting and subject conditions, that may have taken place in the meantime. Beneath the AE-L button is the AF-L (Autofocus Lock) button. Depressing this button when in autofocus mode C will store the last metered distance value until the release button is pressed.

With the lens removed, the seven contacts for the new AF lenses are located at the top, inside the camera bayonet. These contacts are used to transfer lens data such as lens speed, focal length, setting distance for focusing. These values are then used by the AF computer to calculate the necessary focusing values. At the bottom left of the bayonet is a pivoted metal pin; this is the motor coupling for automatic lens focusing. Above that is a screw cover which protects the contacts for the electrical remote release cable.

Beneath the lens release button is the focus mode selector. M stands for manual focus/focus-assist operation, provided the lens is fast enough. C stands for continuous servo autofocus. In this mode the release will override the autofocus function, i.e. you may release while the camera tries to focus on the subject. S stands for single servo autofocus. In this setting the release will activate the shutter only if focusing is satisfactorily completed.

Looking at the camera from the back and with the back panel opened we see on the left, the film rewind fork, which protrudes into the film cartridge chamber. To the right of it are the six contacts for DX coding. These are used to read the film speed from the film cartridge. The shutter blinds in the middle must never be touched when removing and inserting a film as these are very delicate and touching them could cause irreparable damage. Accessories available for the viewfinder are correction lenses, eye cups, and an eyepiece cover that has to be attached to prevent entry of stray light during long exposures.

To the right side of the camera interior is the automatic film threading device. This consists of the film take-up spool, the chromed film guide track and the film sprocket roller. The red marker is the film leader index and indicates how far the film has to be pulled out from the cartridge to be properly inserted. The back panel can be removed and may be exchanged for a databack when the four gold contacts will then serve to transfer the appropriate data. The film pressure plate in the back panel also must not be touched, as the film will not lie completely flat if the pressure plate is distorted. Closing the back panel you can see through the film window if a film is loaded. A special feature that was introduced with the F-301, and is now also incorporated in the F-501, is the film advance indicator. This rotates to show that the film is properly loaded and is advancing.

Looking at the camera from below, there is very little of special note. On the right is the screw which unlocks the battery compartment. To the left is the tripod socket, which is not in the centre as with most cameras because of the battery compartment. This could cause poor stability and it is advisable to use only tripods with large heads, or at least an extra washer, or else the Nikon tripod adapter AH-3.

Now let's look through the viewfinder! At the centre we see the outlines of the rectangular metering field which is the autofocus target area. The 12mm diameter circle indicates the area of centre-weighted light metering. The matt field of the

focusing screen is especially useful when manual focusing is necessary. On the right is the display panel with the red LEDs indicating the shutter speeds, under- and overexposure indicators, and also the green "flash-ready" indicator and flash control for TTL flash metering. In the centre, beneath the viewfinder field, is a green LED that serves as a focusing indicator. If this diode lights up, it indicates that focusing is satisfactory. If the arrow on the left is illuminated, it indicates that the setting is too close; if the one of the right lights up then it is too far. The red warning cross at the far left indicates that the lighting conditions, the subject contrast or the particular structure of the subject is unsuitable for automatic focusing.

The Nikon Bayonet –
Still Suitable for AF!

Nikon was one of the first large camera manufacturers to equip their reflex cameras with bayonet fitting lenses; this was in 1959. It then represented the forefront of technological achievement, but with the advance of camera technology, especially electronics, it presented some difficulties. These have now been solved, so you need no longer concern yourself about any little peculiarities. You can use any modern Nikon lens, or even lenses from other manufacturers that have a suitable bayonet fitting. However, to make use of the automatic focusing facility you will have to use Nikon-compatible AF lenses. Otherwise one can say that as long as you use one of the modern AL-S lenses (recognisable by the lens type identification mark and the orange f/number for the smallest aperture on the diaphragm setting ring) the F-501 will function properly in all operating and exposure modes. Lenses which do not belong to the AL-S group cannot be used in automatic mode. But a solution is offered even in this case; they may be rendered compatible by means of the AF Converter TC-16A. A precondition is, however, that the lens must have a speed of at least f/2.8. Normal lenses can be used with the F501 in manual

focusing mode. Down to a lens speed of f/4.5 it is even possible to make use of the electronic focus indicator with them.

The special feature in the F-501 is the additional provision in the bayonet of a coupling from the camera for motorized focusing of the lens, and the seven control contacts. These have been located so ingeniously that they are completely compatible with the conventional Nikon bayonet. The control contacts are only used for the AF lenses.

The Shutter

The shutter of the F-501 is a vertical, electronically-controlled, metal focal plane shutter. Because the shutter travels vertically across the shorter side of the film, and because of the special blade construction, a shutter speed of $1/2000$ second is achieved. Similarly, a relatively fast shutter speed of $1/125$ second is possible for synchronised flash.

The exposure times are produced by two shutter blinds which operate in sequence. An exposure time of 1 second is obtained as follows: the first blind, which covers the film completely, opens relatively quickly and exposes the film to the light. Exactly one second after the first blind was released, the second follows and covers the film. The area of the film which was exposed first is thus covered first, ensuring a uniform exposure of the whole area, being 1 second in this case.

It becomes more complex for shorter exposure times; the shorter the time, the sooner the second blind has to follow the first. For example, with an exposure time of $1/125$ second, the first blind starts and reaches the other side just when $1/125$ second has elapsed and the whole film frame is exposed. At this instant the second blind follows. This means that for times which are shorter than $1/125$ second, the second blind has to follow the first even before the first has reached the other side. Thus for times shorter than $1/125$ second the exposure is not obtained by one single opening of the shutter over the whole area of the frame, but by a slit moving across the frame.

The Nikon bayonet

a The aperture fork, now only of
 historical value, does not appear
 on AF lenses, replaced by
 aperture cam.
b Bayonet on camera body
c Bayonet on lens

1 Aperture cam for transfer of
 aperture value or aperture value
 coupling
2 AF contacts
3 Lens-type mark (identification
 mark on all Nikon lenses)
4 Bayonet lock
5 Focal length contact or focal
 length·control cam
6 Lens speed contact or control
 cam
7 AF motor coupling
8 Auto diaphragm lever
9 Aperture scale
10 Distance scale
11 Distance scale window
12 Infrared compensation index for
 focusing with IR films
13 Depth-of-field scale
14 Aperture/distance index, lens
 alignment marker
15 Focusing ring
16 Aperture lock
17 Lens housing
18 Aperture ring

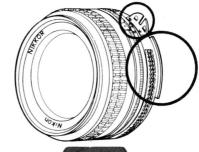

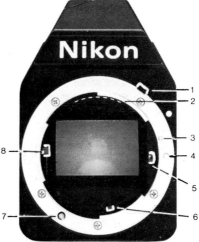

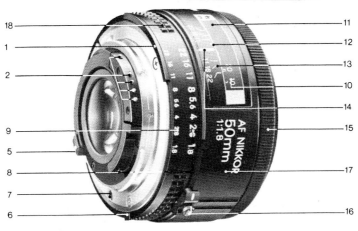

19

The shutter is a focal plane shutter; this means that the length of the exposure time will be determined by the speed at which the slit traverses the film frame, and also by its width. The shortest time for which the shutter is still completely open will depend on the maximum traversing speed achieved by the two blinds. As the vertical travelling time is relatively short for focal plane shutters, the F-501 achieves its shortest exposure time, still with full slit width, at $1/125$ second, and with minimum slit width it could have achieved a speed of $1/4000$ second. However, Nikon's decision not to provide this very short time for the F-501 was probably right; these super-fast times would have increased the price of the camera beyond the means of many an amateur photographer.

For the above reasons it follows that the shortest shutter speed for flash is also $1/125$ second. The flash should be activated only after the shutter is fully open, which in the case of the F-501 is $1/125$ second or longer. If the flash is activated before the shutter is completely open (i.e. at times shorter than $1/125$ second), it would result in incompletely exposed frames.

Film Speed Influences Metering and Setting Range

The national film speed Standards, ASA, BS and DIN, have been superseded by ISO speeds (International Standards Organisation) which are recognised the world over. ISO speeds are stated thus, 'ISO 200/24°'. Two scales of numbers are used, arithmetic and logarithmic, the latter having the degree sign to distinguish it from the arithmetic speed number. The Nikon F-501, like other Nikon cameras, has a scale of arithmetic ISO speeds from 12 to 3200 for non-DX-coded films and from 25 to 5000 for DX-coded ones. The scale of ISO numbers is divided into one-third stop intervals so that intermediate speeds, e.g. ISO 125, can be set up accurately. The old ASA numbers and the newer ISO numbers are

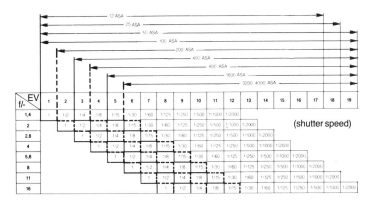

The metering and setting range of the F-501 is shifted with film speed.

absolutely identical and are interchangeable. The selected film speed affects the measuring and adjustment range of the camera electronics. For a setting of 100 ISO this ranges officially from an exposure value 1 (corresponding to an aperture of f/1.4 and 1 second exposure) up to exposure value 19 (aperture f/16 at $^1/_{1000}$ second). I carried out some tests and managed to get adequate exposures with the F-501 with an aperture setting of f/32 and an exposure time of $^1/_{2000}$ second (exposure value 21). At the long exposure end of the scale the metering and setting range is also greater than the 1 second stated by Nikon. This means that the longest possible exposure time is about 28 seconds for 12 ISO, which reduces to about $^1/_4$ second for 3200 ISO. Very fast films therefore are not particularly suitable for the F-501 if you wish to take a series of pictures with long exposures.

Integrated Motor –
Great Advantages

I must admit that I have never been a fan of winders and motor drives. In most cases these "film destruction devices" are too loud to take candid shots. The motor of the F-501 is fully

Setting for motorised film transport in focus mode C, continuous servo function. This allows interesting sequences with autofocus with flash and also for studies of moving subjects

integrated and therefore its operation is much quieter than for many other cameras that use a separate motor. Regardless of this improvement, its whirring is still quite noticeable. This little difficulty can be overcome if you want your subject to be unaware of your activity by taking into account beforehand that a snapshot has to be right first time. On the other hand, the integrated motor has its advantages.

Just consider automatic film loading, which works perfectly with the F-501. Then there are the pleasures of being able to take series shots of moving objects. I found the motor drive a perfect tool when trying to catch a wedding party spilling out from the church. It is also an excellent aid for reproductions and taking macropictures. Advancing the film manually could mean that the carefully set up camera would be moved. In such circumstances the use of the Electric Remote Shutter Release MC-12A is the ideal solution. If you wish to work at a greater distance than 3 metres (the length of the remote release), for example if you are hiding the camera in the undergrowth to catch a shot of some rare animal, then you could use the a remote control release. Either the Infra-red Control ML-1 (60m range), or the Radio Control MW-1 (up to 700m range). You can even employ a timer (Intervalometer MT-2) for exact, pre-programmed time intervals. The latter would be useful in a laboratory to record the progress of an experiment.

Aperture and Shutter Speed Equal Exposure

How is a picture created? If we examine the factors in their logical relationship we should arrive at a reasonably simple answer. We start with the brightness of the subject, and this in turn is indirectly dependent on the intensity of the illuminating light source. If we think of outdoor photography we will appreciate that it makes a difference if the subject is in bright sunshine, if it is spring, summer, autumn or winter, what time of day it is, and whether it is cloudy or not. Artificial light sources too are of varying quality: there is a considerable difference between a tungsten lamp and a photographic halogen lamp.

Therefore let's first consider the light source. The light falls onto the subject and is reflected. The part that you can observe through the viewfinder is exactly the same as passes through the lens and exposes the film. The brightness of the image projected onto the film plane depends on how much light is allowed to pass through by the lens. This in turn is adjustable by a variable-sized opening at the front of the lens – the so-called iris diaphragm which controls the aperture. Practically all modern diaphragms are constructed of tiny blades which are adjustable, forming a greater or lesser circular opening. The larger the aperture opening, the brighter the image that is projected onto the film plane; the smaller the aperture, the darker the image.

Standard aperture values, i.e. size of aperture opening, have been defined to allow a comparison between lenses, regardless of type and focal length. These aperture, or f/numbers apply to any lens, regardless of whether it is used with a 35mm camera or a medium format camera, whether it is a wide-angle or telephoto lens, or whether it was manufactured by Leitz or by Nikon. The image projected on the film plane will be equally bright for the same subject brightness and f/number. When we talk about lens speed we mean the amount of light allowed through a lens at its greatest

23

possible aperture. A lens with lens speed f/2.8, for example, can be opened up to aperture f/2.8 at the most. An internationally standardised sequence of aperture values was devised to provide a comparable f/number sequence for manual exposure settings. This is a geometrical series of light intensities, where each aperture value is always half that of the previous value.

INTERNATIONAL APERTURE (F-STOP) SERIES

<div align="center">

1 1.4 2.0 2.8 4.0 5.6 8
11 16 22 32 45 64 90

</div>

But the subject brightness and aperture value are not the only factors that determine the amount of light necessary for a photographic representation. The length of time the light is allowed to act on the photographic emulsion is the other determining factor. The formula to calculate the exposure is therefore:

exposure = intensity of light x duration of exposure

I am sure you already know that the duration of exposure is controlled by the shutter. Depending on the selected shutter speed, the amount of light will be projected onto the film surface for a shorter or longer time. It makes no difference if we call it exposure time or shutter speed, it means the same. The shutter speed, or exposure time, is also standardised for manual setting by the so-called international shutter speed sequence:

INTERNATIONAL SHUTTER SPEED SEQUENCE

<div align="center">

... $4s$ $2s$ $1s$ $^1/_2s$ $^1/_4s$ $^1/_8s$
$^1/_{15}s$ $^1/_{30}s$ $^1/_{60}s$ $^1/_{125}s$ $^1/_{250}s$
$^1/_{500}s$ $^1/_{1000}s$ $^1/_{2000}s$ $^1/_{4000}s$...

</div>

Here too, the steps are chosen so that the exposure is multiplied by 2 (or halved) from step to step. Some of the values were rounded up or down to obtain round figures.

Subject brightness, aperture value and shutter speed result

in exposure value, but this still does not ensure that there will be the correct level of exposure. The photographic effect of the exposure also plays an important role, i.e. exposure also depends on the sensitivity of the film to the light. Film sensitivity – the film speed – is stated in DIN or ASA values, or as is standard today, in ISO notation. The larger the ISO value, the greater the film speed.

ISO SEQUENCE FOR FILM SPEED

12/12°	25/15°	50/18°	100/21°
200/24°	400/27°	800/30°	1600/33°
	3200/36°	6400/39°	

Again, the film speed is doubled (or halved) from one value to the next. It is possible to obtain films with intermediate values, as for example, the well-known Kodachrome 64 with ISO 64/19°.

In conclusion one can say: low subject brightness and low film speed necessitate large aperture openings (i.e. small f/numbers) and slower shutter speeds. Great subject brightness and fast film speeds require small aperture openings (i.e. large f/numbers) and faster shutter speeds.

If we consider a fixed subject brightness and a fixed film speed, then we can produce the same exposure level by opening the aperture and selecting a faster shutter speed, or, alternatively, by stopping down the aperture and selecting a slower shutter speed. Assuming you expose for $^1/_{125}$ second with aperture f/2.8, or aperture f/8 and $^1/_{15}$ second, it will make no difference; the exposure, i.e. the effect on the film, will be exactly the same.

Light Metering is the Key

Only if the camera's microcomputer is completely informed about the amount of light coming from the subject will it be able to expose automatically in any of the available program modes.

Exposure metering in the F-501 is heavily centre weighted, about 60% of the light is metered in a 12mm dia. circle at the centre (the figure shows the results of a test by the magazine "Photo Revue")

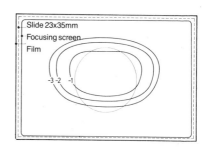

And if you wish to perform the settings manually, then you will also have to take a light measurement of your subject. It follows therefore that first you measure, then you expose. But it is not nearly as simple as the term "measuring" might imply. It depends on whether you wish to expose the whole frame evenly, or if you are mainly interested in the central subject, or perhaps only in certain areas. We therefore talk about integral overall field measuring, centre-weighted integral measuring and spot measuring.

The measuring preference of the F-501 is best described as strongly centre-weighted integral metering. In all shooting modes the camera measures in such a way that the centre 15% of the picture area contributes about 60% to the total light measured, the remaining 85% contribute only 40%. Towards the edge, the contribution to the measurement decreases progressively so that the immediate edge contributes practically nothing to the overall value. In most cases this is the best method, as there are often very bright areas at the edge of the frame, such as a light sky. If the sky were to be measured equally with the rest of the subject then an incorrect exposure value would be produced. On the other hand, the centre of the frame generally contains important elements in the composition of the picture and so the exposure of this area is critical.

Let's consider the situation of taking a person against a bright sky. If the camera measures the entire frame it could easily interpret the whole scene as very bright and consequently underexpose the person, the main subject.

However, if the person is measured in the middle of the frame with centre-weighted integral metering, it should be possible to produce the correct exposure without any problems. Why not buy a few cheap slide films when trying out your new F-501?

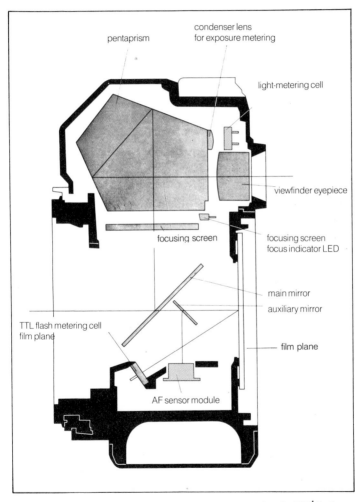

condenser lens
for exposure metering

pentaprism

light-metering cell

viewfinder eyepiece

focusing screen

focusing screen
focus indicator LED

main mirror

auxiliary mirror

TTL flash metering cell
film plane

film plane

AF sensor module

Path of light in the F-501 for centre-weighted exposure metering, for TTL flash metering and for AF focusing metering.

The quality does not matter too much at this point, just go out and take a few experimental shots of some difficult situations. This will help you to develop a feeling of how your camera behaves in these situations. The experience will be invaluable later on when it is critical to know when to rely on the camera's automatic responses and in which situations it is advisable to make certain corrections. I have included more hints on this subject in later chapters of the book. A practical help for this purpose is the 12mm central circle defining the area which contributes 60% of the brightness value.

Plenty of Power for Motor and Autofocus

The sister model of the F-501, the F-301, used just one motor for film transport; the F-501 has another motor to take care of the automatic focusing of the lenses. Therefore it will not come as a great surprise to learn that you will have to put some batteries into your F-501. The only question is, how well have Nikon solved the problem of energy supply? Very well, it seems. Four AAA, or as an option, AA cells supply not only the two motors of the F-501, but also the camera's electronics for metering, setting, and operation of shutter and mirror. The supply voltage of 6V (4 x 1.5V) is ample. This is on the assumption that as long as there is enough energy for the motors, there must be plenty to measure the lighting conditions. My own measurements have justified this assumption.

According to my experience, the camera requires an open circuit voltage of at least 5.2V (i.e. 1.3V per cell). If the voltage is lower than this before activating the shutter, then it may be possible that the camera will no longer release the shutter. If it does activate the shutter, then it is still quite safe, even with low batteries, because the exposure reading and triggering of the shutter itself requires scarcely any energy at all; the main drain on the energy level occurs when the exposure has been made

It is advisable to buy the battery holder MB-3 as an accessory so that you can use size AA batteries with the Nikon F-501.

and the motor is activated to move the film to the next frame (400 mA or more).

If the batteries break down and drop below the minimum voltage requirement because of the heavy load imposed by the motor drive, then this is still no great tragedy. They will recover and you can take another picture. In emergencies it is possible to take quite a few exposures even with nearly run-down batteries, without incurring the danger of incorrect exposure. You will have to wait, though, between frames until the voltage level recovers sufficiently. This is no tip for the Scrooges amongst you – I DO mean in an emergency!

Nikon specify the use of alkaline batteries in AAA or AA sizes, or nickel-cadmium rechargeable batteries of the appropriate size. Unfortunately it is not possible to use the AA size, or rechargeable batteries, without first having to make a slight adaptation because the battery compartment is about 2mm too shallow. If you get the base plate MB-3, referred to by Nikon as the battery holder, then the larger batteries will fit perfectly and they do have a distinct advantage. The AAA size batteries under ideal conditions last for 40, 36-exposure films. This sounds quite impressive. But if you use AA size batteries you can shoot 120 films, and this sounds even better! My own experience confirms the much better performance of the AA size batteries. There is absolutely no difference between fresh batteries of either size, but with even slightly-used AAA batteries, whose voltage has dropped to about 1.4V, there is a clear loss in performance. My camera using AAA-size batteries started to experience intermittent difficulties after some consecutive shots, but when AA-size batteries in the same partly-used state were in the same camera it worked perfectly.

If one considers how long batteries are sometimes sitting on the shelf before they reach the customer, and that they discharge slowly in the camera even when they are not used, then it is not surprising to find that they can be in a worse condition than one might reasonably expect. The AA-size batteries afford a certain safety margin. Freshly recharged nickel-cadmium batteries also proved satisfactory, but as they do not hold their charge for long periods, they have to be recharged frequently and always before use if the camera has not been used for some time.

If you have already been using electronic cameras you will know that the batteries' greatest enemy is the cold. This applies to most batteries used in cameras, which are generally severely undersized button cells. Here too the F-501 is a praiseworthy exception; equipped with four fresh AA-size batteries it will work in temperatures down to -18°C (directly from the freezer!). I cannot furnish you with a guarantee that you can do the same with your camera, but down to -10°C should be no problem, using fresh AAA- or AA-size alkaline or freshly charged rechargeable batteries. Only you cannot expect the same output as under normal temperatures, you will have to be satisfied with $^1/_3$ to $^1/_6$ of the number of exposures per battery set under such extremely cold conditions.

Which are the best batteries for the F-501? I would advise against the use of AAA batteries, as they are relatively expensive, not easily obtainable, especially on holiday, have often sat on the shelf for a considerable time before you buy them, and do not last nearly as long as AA size batteries. The use of the generally-available, relatively cheaper, AA batteries seems to me the best solution. Only the alkaline batteries are recommended in either of these sizes. The much cheaper zinc-carbon batteries should be used only in absolute emergencies and should be replaced by alkaline batteries as soon as possible.

The following iron rules for the handling of batteries in the F-501 should be observed:

○ AA-size batteries last longer than AAA-size.

○ Always buy fresh batteries. Check the date on the batteries or ask your dealer to check the voltage.

○ Change the batteries at least once a year for a completely new set. Even if the camera was not used, the batteries discharge in the compartment.

○ Always keep a set of 4 fresh batteries at the ready and in winter they are best kept in a pocket.

Another piece of good advice: the automatic cut-off controlling the viewfinder L.E.Ds serves at the same time as a battery level indicator. If the L.E.Ds are extinguished only after about 8 seconds then the batteries are good; if after less than 4 seconds then you should make a note to change the set; if they are extinguished after only 1 second then your batteries have reached the minimum level.

Film Loading Like Lightning

Now that we have become familiar with the camera we can start to think about taking pictures. Loading the film should present no problems, even right at the start. You can be totally left-handed with the F-501; put the film in the chamber, hold the camera in the left hand and hold the film down with your left thumb, pull the film end with your right hand until it reaches the red marker, check whether the sprockets are aligned with the transport perforations of the film, close the camera back, and depress the shutter release. The film will be automatically advanced to frame 1. The only problems that you could possibly encounter are if the film has been pulled too far, or not far enough. I have loaded a considerable number of films into the F-501 and found that one millimetre more or less makes no difference. Whether or not you have loaded the film properly is immediately obvious with the F-501. One glance at the film transport disc on the back plate is sufficient.

Rewinding the film is also very easy. Push the rewind safety catch to the right, depress the R-button and fold out the rewind

To load a film, pull film leader out to red index mark, ensure that the perforations engage in the sprockets, close back, release. The motor transports film to frame 1.

crank, then turn in the direction of the arrow. The end of the film is reached when the film transport disc stops. I always turn a little more to ensure that the film is fully rewound into the cassette. This has the advantage that I could never mistake an exposed film for a fresh one. I am also afraid that the film might be yanked out of the cassette when sent for processing. The protruding end may make life easier for the assistant, but pulling the film out in this way could cause scratches and dust-attracting electrostatic charges, or even sparks.

If it is a high-speed film, about ISO 1000 or faster, it could happen that if the film is completely returned into the cassette, light enters through the narrow slit and the first few frames may be fogged as a result. As a precaution I would not completely rewind the very fast films. Alternatively, place the film immediately in the light-tight container or wrap it in some aluminium foil to keep it safe.

Perspective with the 20mm wide-angle lens. The converging lines in the photograph at the top increase the impression that the buildings are precariously balanced on a steep mountainside. The beach huts at the bottom gain special interest by the heavy emphasis on the foreground. Photo: Wolf Huber

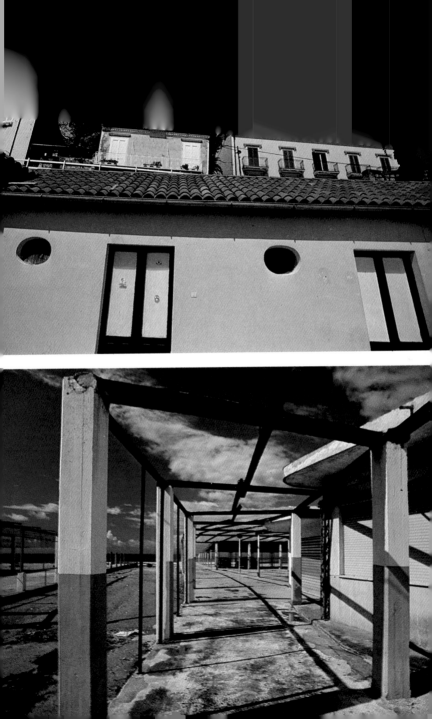

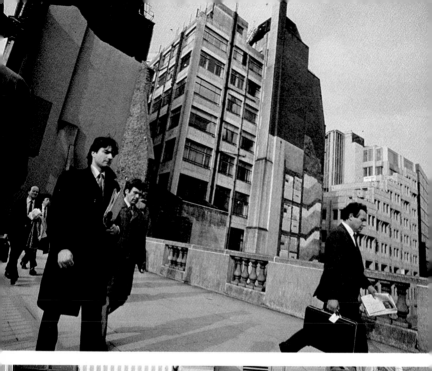

Don't Always Rely on Automatic DX Setting

The F-501 has, like most other modern cameras, the facility to read the film speed automatically. Most makes of film now include a coded, machine-readable information strip for this purpose. The code includes the visible bar codes (black lines) indicating manufacturer, type of film and film speed which are primarily intended for processing purposes at the lab. There is also the resistance code which is conveyed by polished metallic (low resistance) and painted (high resistance) areas which are interpreted by the camera and directly transferred via electrical contacts into the exposure microcomputer.

If you use the DX setting on the film speed dial, you won't have to worry about anything else. From that moment the camera will read the correct film speed and automatically adjust the meter readings, provided the loaded film bears the DX-codes. But even if you buy a film that has no DX-code it should present no great problem. The F-501 will quite simply refuse to activate the trigger and instead it will set off the warning light and the audible bleeping alarm. However, the F-501 is not infallible. If the air humidity is very high, or if the DX-codes on the film cassette, or the DX-contacts on the camera, have been touched with sweaty fingers then it could happen that the information is mis-read. Under these circumstances the camera would not give any alarms. The DX-coding guards against forgetfulness, but unfortunately the only solution in this situation is to revert to manual setting of film speed.

In any case, no-one who wishes to make use of all the possible photographic tricks would wish to do away with manual selection of film speed. For example, you might wish to

Typical snapshots. A city scene in London, shot from the hip with a 20mm wide-angle lens, the diplomat's briefcase seems to have replaced the bowler hat and rolled umbrella! The buskers were taken with a 28mm wide-angle from close-up. *Photo Wolf Huber*

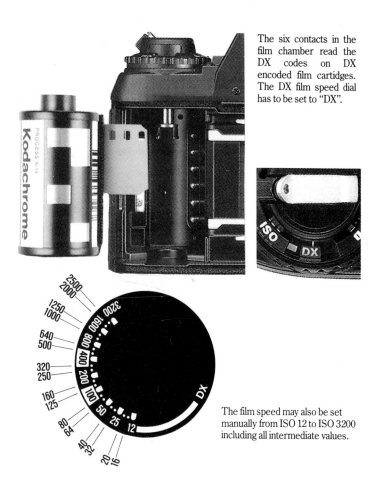

The six contacts in the film chamber read the DX codes on DX encoded film cartidges. The DX film speed dial has to be set to "DX".

The film speed may also be set manually from ISO 12 to ISO 3200 including all intermediate values.

expose your 200 ISO colour print film under certain circumstances as 100 ISO, or perhaps your experience has shown that your 64 ISO colour slides produce better results if they are exposed as 50 ISO.

So far, so good. But what type of film should be loaded into the F-501? A colour print film, a slide film, a very fast or a very slow film, or a black-and-white film?

Colour Slides or Prints – Not a Question of Faith

There is no doubt that the great advantage offered by colour slides is the excellent quality of the projected pictures. A large projected image of a good quality slide gives the best possible reproduction of colour and tones, which is hard to match by any other means. The glowing colours and the fine details in light and shade produce an unsurpassed brilliance and vividness. The reason for this is that slide film is denser and richer in contrast than colour print film. But to achieve the delights that a colour slide can bring require some degree of expertise.

Because slide films are so rich in contrast, which means they are very hard, they are also very sensitive to incorrect exposure. Half a stop under- or overexposure can have adverse effects, especially with high-contrast subjects. Also, if you think you could produce perfect prints from your slides, you will be disappointed. Admittedly, it is quite cheap these days to get prints made and their quality is usually quite acceptable. The problem starts when you want to make enlargements from your slides, as the extent to which they may be enlarged is limited. Also colours which were specially brilliant and clear in the projected image are often reproduced imperfectly. Only images with low brightness ranges and bright poster colours are reproduced equally well or even better as prints than they were as colour slides.

Hence the strength of colour negative film is in the colour prints it can produce. This is true even if the quality of the prints from the large processing laboratories is not always of the best. But this problem also exists for slide film as these too are not always perfectly processed. However, it can generally be said that slide films are usually processed better than colour prints. The reason for this is that the colour print has to undergo three processing stages: film development, enlargement and printing. This means that there are two more processing steps where the quality can vary. But provided the

film was correctly exposed and it was properly processed by the laboratory, you should obtain perfectly good enlargements from both images with not only average but also with high contrast values.

The answer to the question of whether to use slide or print film must therefore be that if you consider prints to be your medium, then you will have to choose print film, but if you value the quality of the projected image, then you will want to use a slide film. If you like both, then you have to use them alternately – or perhaps use a second camera body to be able to use them both at the same time.

How Critical is Exposure with Colour Film?

As mentioned previously, colour print films are less sensitive to incorrect exposure than colour slide films. Of course you should always strive to expose correctly. You will achieve this with a colour print film if you work to the motto: Rather over-than underexpose. Colour print films which were overexposed by up to one stop usually turn out very well, or even better with respect to saturation of the colours, sharpness and graininess than those which have been exposed minimally. However, the quality usually deteriorates very quickly if a colour print is underexposed. Therefore if you set the film speed to 100 ISO when a 200 ISO film is loaded, or if you use an exposure correction of +1, then you will always obtain very good results for subjects which are on the flat side, i.e. which have a limited contrast range. Only if your subject is rich in contrast, i.e. has great variations of dark and light, is it important to revert to the nominal exposure value. Meanwhile there are colour print films available that take account of this factor by stating a nominal film speed which lies lower than the actual speed of the

The enthusiastic conductor of a small choir and the market trader were both taken in reportage style with a modest wide-angle and from a reasonably short distance to convey the feeling "of having been there". Photo: Rudolf Dietrich

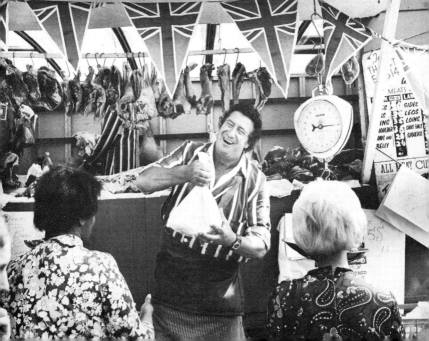

film. The Agfa XRi, for example, is one of these, stating a nominal speed of ISO 100, whereas in reality its speed is nearly twice as fast. If you are using one of these films you have to keep the nominal setting at the stated value and have to do without the occasional trick of intentional overexposure.

The correct exposure level is much more important for colour slides and this means also the correct setting of film speed. Contrary to some well-meant advice, it is very important to expose colour slide film at the correct level. In so far as the setting of the film speed is concerned, which after all is the underlying condition for correct exposure, you will usually find that the specified speed is the best setting. In individual cases it might be possible that the sensitivity of the slide film departs to a small degree from the nominal speed. There are several types of films where the speed is not correctly stated by the manufacturer. If you find that your pictures for one type of film are consistently either too light or too dark for subjects with average contrast (1:32), then you should adjust the speed setting for that type of film in the future.

Do High-Speed Films Give Good Results?

It is true that the quality with respect to sharpness and graininess of the modern 1000 and 1600 ISO films offered by many manufacturers is surprisingly good. But technological progress increases our expectations and the quality of lower speed films has improved in line with that of the high speed films. The latest wave of improvements has brought forth a range of low- and medium-speed films of excellent quality, such as the "Gold" (Kodak), "SuperHR" (Fuji) and "XRi" (Agfa) films. To obtain maximum sharpness and colour saturation you should continue to use the 50, 64 and 100 ISO films. If you want to be prepared for all, or most, eventualities, then the 200 ISO is a good bet. If you are taking pictures under low lighting conditions, or if your subject is moving fast, perhaps in sport or

play, then you would be well advised to use a 400- or even a 1600 ISO film. Even if you are holidaying in the sunny south it is always a good idea to have a few fast films handy. After all, what can you do with a 64-ISO at the bullfight or for underwater photography?

The competition among film manufacturers has increased in recent years to such an extent that there is now a wide range of excellent films available, offering a variety of characteristics. Which film is the best for you cannot be decided objectively, the colour preferences alone could give rise to heated discussion. You have to try yourself and see which suits your taste.

Which film for which photographic situation is a different question of course. It seems quite obvious that if you photograph in low lighting conditions the best films to use are the 1000 ISO and 1600 ISO films. However, be careful not to overestimate the ability of these speed ratings. In a normally-lit living room, using a 1000-ISO film, you cannot get any lower than f/2.8 and $^1/_{60}$ second and the lighting conditions in a normally lit gymnasium would not be much better. Even very bright floodlight will gain only a few stops.

Another aspect that is often not sufficiently appreciated is the irregular, poorly-lit area of a general subject. It is possible in individual cases to produce a lovely romantic image of a subject lit by candlelight, but usually these efforts are quite worthless even with a 1600 ISO film. Fast films replace a flash only in certain situations. Of course, it is not always possible to use flash. But even then I would think twice before reaching for the 1000- or 1600-ISO film, even if camera shake is a real problem. Although some of these films are surprisingly fine grained, they are all comparatively poor in colour reproduction. The question is always whether a gain in film speed of one or two stops is worth the disadvantages of the very fast film, compared with a 400 ISO film.

Black-and-White Is Back Again!

Almost everybody starting photography these days uses

colour and does not bother with the roundabout route of black-and-white. This is justifiable and understandable. Modern colour photography presents comparatively few problems and is relatively cheap compared with the traditional black-and-white process. Badly developed colour slides are a rarity, and if you use colour print film you usually get at least reasonable quality from your processing lab. Today, black-and-white prints of equal or even better quality are almost out of the amateur's price range.

Black-and-white photography is an art in itself. The colours and contrasts of the subject have to be translated into tones of grey. Nevertheless a good black-and-white picture lacks nothing; some subjects are even better in this form than would be possible in colour. But if you wish to express yourself in this medium you will almost certainly have to set up in your own darkroom and do your processing and printing. It starts with developing your own film, which has to suit the subject taken and the type of film used, and then you have to use the correct type and grade of paper to produce a good enlargement. Then there is a whole range of little tricks such as shading, masking, and so on. But this necessity to print your own pictures if you want black-and-white need not be a disadvantage; on the contrary it can be a great source of enjoyment and satisfaction.

If you want to try black-and-white photography for yourself, then I would recommend you to get Ilford XP-1 universal black-and-white film. This is a monochrome film using colour technology. It handles high contrast subjects and is relatively unaffected by incorrect exposure. You can get it developed by one of the large photographic laboratories where you send your colour films, or in some countries you can send it direct to Ilford in the envelope provided, who will return your developed film together with a sheet of contact prints. This last service is not available in Britain however.

Focusing –
Nothing could be Simpler

In the past, the difficulties they experienced in proper focusing have prevented more amateur photographers from seriously engaging in SLR photography than you may think. The success that the compact cameras have had can be attributed to a large extent to the fact that focusing with them is done automatically or is not necessary at all. That this was indeed the case is demonstrated by the fact that many good and easily operated 35mm viewfinder cameras came on the market but could not compete with the simple snapshot cameras. The break-though by the 35mm format cameras against the pocket and disc cameras was achieved only after automatic focusing was incorporated as standard in 35mm viewfinder cameras. This success led to eager efforts by the SLR camera manufacturers to incorporate automatic focusing into their cameras.

In principle there were several measuring methods available for the SLR camera. One possible approach is to use active distance measuring by means of an ultrasonic or infra-red beam, an alternative is the passive assessment of sharpness within the camera of the image projected by the lens. Ultrasonic measuring has proved very successful with Polaroid cameras, but the range and targeting accuracy is not sufficiently precise. This is not a disadvantage with the usual instant pictures in the close range of 2 to 5m. The infra-red metering system has proved to be the most successful with 35mm viewfinder cameras. It is very precise and is not liable to incorrect results, but it is less suitable for greater distances.

Measuring larger distances increases the energy requirement and therefore the drain on the battery power. The distance has to be measured fairly precisely for distances up to about 10m with 35mm viewfinder cameras with their relatively short focal lengths of about 40mm. For larger distances a setting at infinity is sufficient to ensure sharp focus. But if one wanted to focus a telephoto lens of say 500mm focal length by

infra-red autofocus, the range of the autofocusing system would have to extend to about 80 metres. This would be possible but rather difficult within the constraints of a small camera.

Contrary to these active measuring systems, in which some form of beam is sent out, either ultrasonic or infra-red, and the reflected beam is measured, the trend in SLR cameras was towards passive distance measuring. In this case the distance measuring system is incorporated in the camera and in effect measures the sharpness of the viewfinder image. To simplify somewhat, we can say the camera's microcomputer measures the blurring of the viewfinder image for incorrect settings and calculates from this the required lens adjustment. This is then passed to the microcomputer controlled motor in the camera which then transmits the required movement mechanically to the lens.

After Minolta brought out their autofocus SLR camera, Nikon followed as the second manufacturer in the field by introducing their F-501 as a new generation AF camera. I must admit that initially I was very sceptical as far as AF systems were concerned, but the F-501 did not take long to convince me of the precision and speed of the AF facility. There are, of course, situations where the autofocus cannot cope, and I shall describe these in a separate chapter. But in the majority of situations automatic focusing proved to be excellent. Getting sharp pictures is no longer a question of good eyesight and is simpler than it has ever been before.

Viewfinder With Interchangeable Focusing Screens

The image of the subject, projected via the mirror onto the focusing screen in the viewfinder is used for focusing purposes in all 35mm SLR cameras. The length of the optical path to the focusing screen is exactly the same as that to the film plane when the mirror is folded away, and the sharpness of the image

The focusing screen can be exchanged quite easily. It may be replaced by a reticule screen with AF metering field (Type E, left) or a focusing screen with microprism field (Type J, right), the latter is suitable for manual focusing with longer lenses and in poorly-lit situations.

in the viewfinder is therefore a precise indicator of correct focusing. In principle a normal ground glass screen would do to perform this function; it should not be too coarse and should be evenly grained. The F-501 has such a focusing screen. It is most suitable for manual focusing, although you will seldom need to make use of it thanks to the autofocusing facility. The absence of the additional focusing aids such as split screen indicator and microprism ring are a great advantage. The image in the viewfinder becomes rather dark with these aids when focusing on dimly-lit subjects, or when using a particularly long lens, and instead of aiding the process, they make it more difficult. The standard focusing screen of the F-501 presents no problems in this respect. I was able to focus quite well even in the dusk with an f/8, 500mm lens. Those of you who have good eyesight, or a good pair of glasses, can focus manually with this focusing screen, even in conditions where the autofocus fails.

Even so, there are two further focusing screens available as accessories for the F-501 and it is quite easy to change them. The autofocusing facility of the F-501 functions only with lenses of maximum aperture f/4.5 or greater and so Nikon

offers Focusing Screen J for use with the slower lenses. This screen is a bright image Fresnel lens and has a microprism field as the focusing aid at its centre. It is the ideal focusing screen for use with slower lenses where the autofocus is unable to help. But the J-screen is not particularly suitable for lenses slower than f/8. For this reason I am not very convinced of its usefulness as it offers only a limited improvement over the standard focusing screen which is supplied with the camera.

The ideal complement to the autofocus facility, in my opinion, is the E-type focusing screen. This too is a bright image Fresnel lens with the outline of the autofocus metering field and a line grid. The grid is useful for wide-angle shots as it clearly shows the effect of converging verticals. It is therefore the ideal screen to use with shift lenses. I also find it very handy for photography of subjects at close range and also for making reproductions when the camera has to be properly aligned. I always use this type of focusing screen in my own camera.

The other focusing aids that are offered for the F-501 are useful or necessary, such as correction lenses and a viewfinder magnifier. The correction lens is handy for those who have difficulty in seeing the viewfinder display with their normal glasses. They are available from Nikon in dioptre graduations of -5, -4, -3, -2, +0.5, +1, +2 and +3. Inserting them in the viewfinder eyepiece is very easy.

Two Autofocus Modes, One Focusing Aid

Setting the focus mode selector to S makes an unsharp picture a thing of the past. In this mode automatic focusing takes precedence over shutter release. In effect this means that you aim at the important detail of your subject by placing it within the rectangular focusing field at the centre of the focusing screen, then you press the release button to the level of the finger guard (i.e. not completely) and wait until the green in-focus LED in the viewfinder indicates that the image is in sharp

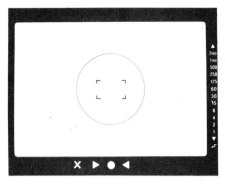

Top: At the centre of the focusing screen are the rectangular field markers for AF-metering; at the bottom the focusing indicator panel

Centre: If the left pointing arrow illuminates, then the distance is set too close, if the green LED at the centre illuminates then focusing is correct, if the red arrow pointing to the right illuminates, then the distance is set too far. The red warning cross indicates "focusing not possible" (too dark, too little contrast, too confusing, unsuitable lens)

Below left: Focusing mode S: release possible only if subject in focus. Below right: Focusing mode C: release possible even when subject not in sharp focus, AF focuses continuously on subject.

too far

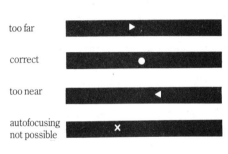

correct

too near

autofocusing
not possible

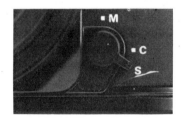

focus. Now you can take the picture by fully depressing the release button. If you try to take the picture before the green in-focus indicator lights up, you will find that the release is locked.

The electronics of the F-501 are highly sophisticated and the

green LED will light up only if focusing is correct. Out-of-focus pictures in focusing mode S therefore are definitely a thing of the past. Shutter release is impossible all the time the autofocus function has not found a satisfactory setting. Similarly, shutter release will be impossible if the lighting conditions are too poor for the autofocus to effect correct settings, or if the subject lacks contrast or contains confusing structures, and also if a non-AF compatible lens is used. In these situations the red warning cross will light up.

Why has Nikon chosen to call this focusing mode "S"? S stands for Single Servo Autofocus, i.e. focusing for a single shot only. This means that if you slightly depress the release button to the finger guard when in focus mode S, and the autofocus has focused on the subject, then this setting is automatically stored as long as your finger stays on the release button. In this mode you can, as long as the green in-focus LED stays lit and your finger stays on the release button, realign the camera to select the desired framing and then make the exposure. There is no problem if you decide against the shot and don't release. Simply lift your finger off the release button for a instant and the stored focusing setting will be cancelled. You are free to point the camera at a new subject and re-start the focusing process by again slightly depressing the release button. This may sound a bit cumbersome, but in actual fact it is really easy.

Not only are the manipulations very simple, the autofocusing facility of the F-501 is extremely fast and well suited for quick snapshots. In this case you point the AF-metering field in your viewfinder at the main subject that has to be in sharp focus and fully depress the release button. The shutter will be released automatically as soon as the subject is in sharp focus. Depending on subject brightness, contrast, distance and lens this could take up to two seconds. In ideal cases it is as fast as $1/2$ second. This trick can also be used for moving subjects as the exposure will only be made when the subject is guaranteed to be in sharp focus. It would be hard to match the speed of the AF mechanism in manual focusing, but, as mentioned above, it is not always as super-fast as this and

the main subject has to be at the centre of the frame, within the focusing rectangle.

The alternative to the S focusing mode in which the correct focus has precedence over shutter release, is the precedence of shutter release over focusing. This is focus mode C. This is suitable for subjects where the required distance setting is continuously changing. In such circumstances one needs the focus to be continuously adjusted as the camera is moved to find a new subject. Not only the camera movement, but also a moving subject may be followed with this setting.

Imagine a bicycle race. With focus mode S you may catch the madly pedalling cyclist perfectly once in the frame. In Af focus mode C the automatic metering and focusing function operates as soon as the release button is depressed to fingerguard position. You need only keep your finger on the release button and the camera will automatically adjust the focus for the section of view within the target area (i.e. every 200 ms). Now you have the choice of waiting until the green in-focus LED indicates the best possible sharpness, and then taking the picture, or else you could take the picture before the focusing sequence has been completed. In my opinion the second possibility is the one that adds interest with moving subjects. After all you could have used the "S" autofocus mode if the subject had to be in perfect focus. The freedom of being able to release the shutter when you consider it best for the desired effect adds an interesting dimension to taking snapshots.

Let's go back to the example of the racing cyclist. He may be holding his head in an awkward position if you take the picture exactly at the point when the autofocus obtains a sharp setting. In C focus mode you can wait until he lifts his head and take the picture just when it seems opportune. The AF facility may not have completed its setting, but if you are working at a high f/number, i.e. a small aperture opening, the subject should still be within the depth of field and therefore in reasonably sharp focus. You can also override the continuous focusing mode in C mode by the use of the focusing memory lock. If the green in-

focus LED lights up in C focus mode and you depress the autofocus lock button, then the last effected setting will be stored until you take the picture, or until the autofocus lock button is released.

If you are using lenses that cannot be adapted for the AF function with the F-501, and provided these lenses have a lens speed faster than f/5.6 (i.e. f/4.5 or better), then you switch to focus mode M. Now you can select the distance manually by adjusting the focusing ring on the lens and the AF function will assist you in this task. In this mode it works as a focusing aid, i.e. if one of the two red arrows lights up when the release button is slightly depressed then this means that the focusing ring has to be turned in the direction of the arrow to adjust the focus. The left arrow indicates that the chosen distance is too great, i.e. move the focus closer, if it is the right arrow, then the distance has to be increased. Manual focusing is reliable and works perfectly. This is one of the reasons why the split screen indicator and microprism ring will not be missed.

If the red warning cross lights up in any of the focusing modes S, C or even M, then this means that the AF system cannot obtain a satisfactory distance reading. The reasons could be insufficient brightness, insufficient subject contrast or confusing subject structures. In this case you have to focus manually on the focusing screen, regardless of whether you are using an AF lens or one of the suitable older-style lenses, if the image in the viewfinder is too dark, then the only possibility is to estimate the distance and set this value on the lens focusing ring. The limitations of the AF system just described are not necessarily a disadvantage. If it is very dark, or if you are using a rather slow lens, then you have no other choice but to use approximate settings, even with a focusing screen with the normal focusing aids.

This sequence was taken in focusing mode C. Lens with focal length 210mm and thanks to the fast 400 ISO film aperture f/8-11 at about $^1/_{250}$sec. All frames reasonably sharp, even though the AF function had not always completed focusing.

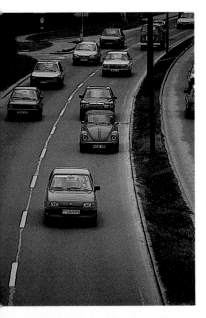
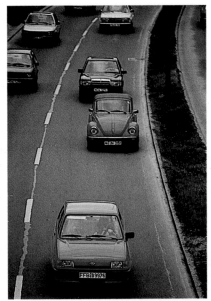
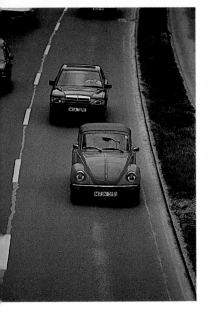

51

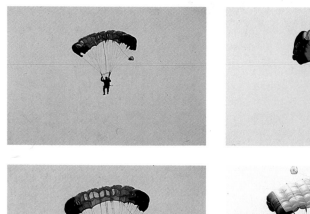

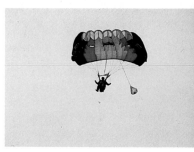

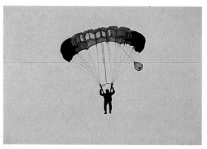

Autofocusing mode S with in-focus priority. This sequence was taken by the AF-Zoom lens at about 210mm, with 400 ISO film, shooting mode A (f/8 and about $^1/_{500}$sec). Film transport set to S. The release was kept depressed and the entire jump was captured from start to finish. The camera released always as soon as the in-focus LED illuminated: the result was nearly 36 perfectly sharp photos.

Correct Use of Autofocus

The continuous servo autofocus mode is ideal as the snapshot mode on holiday, on the beach, in a group of friends. Depending on lighting conditions you should load at least a 100 ISO film but better still one of 400 ISO speed. The shooting mode selector is set to P DUAL. All that is left to do is to point the camera and release the shutter as soon as the green in-focus LED is illuminated. In this mode any blurred pictures could have been caused only by camera shake and that is why I recommend use of a faster film.

Fast shots for sport, dancing, play, etc., in other words for moving subjects, usually turn out very well in autofocus mode C. You will have to use fairly fast films; depending on available lighting conditions they should be at least 400 ISO or even 1600 ISO. As shooting mode you should ·select aperture priority A. This allows you to preselect a small aperture to obtain a relatively large depth of field, such as f/8, f/11 or f/16. Thanks to the release-priority of mode C you can take your shot any time an interesting scene presents itself. Even if the autofocus has not completely caught up or if the main subject is not within the centre target area, the relatively large depth of field should take care of this and you will generally get successful shots.

Properly composed shots, such as portraits, landscapes or architectural pictures are better taken in focus mode S. These shots can usually be taken at leisure. Aim the camera at the subject; ensure that the important detail lies within the target area; depress the release button slightly until the green in-focus LED lights up; keep the button depressed to realign the camera for the required section, if desired; fully depress the release button to make the exposure.

If you are using a tripod, which is always an advantage when taking static subjects, you could take your finger off the release button after the AF mechanism has set the lens, and then switch to M-focus mode. You can now select the required framing without any hurry, as the focus setting is stored. Now

you need not necessarily work at small apertures, but are free to use the most suitable aperture setting for the picture.

AF function S can also be used as a focusing trap for moving subjects. Imagine the object moving towards you – a runner, a cyclist, a railway engine. If you point at this object so that the target area covers the important detail and depress the release button fully, then the camera will take the picture when the object has moved into perfect focus. For some reason or other, such shots are not always successful on the first try and it is worth while to take a sequence of shots. This works perfectly with the F-501. Set the focus mode selector to S and the integrated winder to serial shot position C. Now you only have to aim the camera at the subject and fully depress the release button. The camera will now continue shooting and you could obtain about 1.7 frames of your moving subject per second, and all of them in perfect focus.

The less experienced photographer will select focusing mode S and shoot in program mode. This combination requires no manual settings and the photographer can concentrate fully on the subject. Those of you who are more confident will select aperture priority A and focus mode S. In this shooting mode it is possible to select a larger aperture opening (small f/number) and the main subject will appear more prominently against a blurred background because of the shallower depth of field.

Automatic Focusing in Complete Darkness

There are situations where not only the autofocus goes on strike, but also the human eye. The autofocus flash SB-20 has the answer! This flashgun has an additional special AF-infrared flash in addition to its normal flash functions. This means that if the F-501 is set to AF focus mode S and you depress the release button, the AF flash will send out an infrared flash to illuminate the subject if the lighting conditions are insufficient for the AF mechanism to take a reading. This AF flash will be

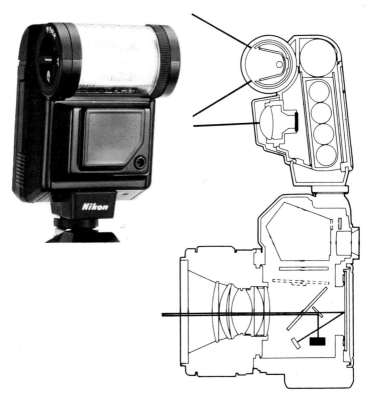

Autofocusing can be achieved in total darkness with the AF flash SB-20. As soon as it is too dark for the AF system to focus, the SB-230 flash emits up to five red light impulses, the illuminated spot on the subject is then used by the AF function to focus. Exposure with TTL flash metering follows.

emitted up to five times until the AF has obtained a satisfactory setting. This arrangement guarantees a sharp flash picture. If you do not wish to expose with the flash you can switch the flashgun off, always keeping your finger on the release to retain the AF setting. You could then change to focus mode M and use the stored AF setting to take very attractive available-light shots in whatever exposure mode seems appropriate for the subject.

The AF flash focusing method has further advantages. The

focusing flash projects a vertical striped pattern on the subject and thus is useful for taking readings on subjects of low contrast. You may consider this facility totally useless because you cannot see much in total or near total darkness. Not so, the visible red part of the IR focusing light and the focusing flashes – impulses to be precise – are long enough to be clearly visible in the dark. Up to 5m away you can make out the object you are focusing on quite clearly. To assess the situation you should not look through the viewfinder but directly at the subject.

Situations where Autofocus Cannot Cope

The method for distance metering used by the AF mechanism is passive. This means that the sharpness of the subject is assessed at the image projected by the lens and the required adjustment of the lens is calculated by the AF-minicomputer. In effect, focusing is based on measuring the image contrast. In order to take such a measurement, the subject has to possess a certain minimum degree of contrast, and also the image generated by the subject through the camera's lens must not be too dark.

In situations like these the AF function cannot decide what is the important detail to bring into sharp focus, the foreground or background. If the foreground, which usually has better contrast, is in the metering field, then the AF function will focus on those details.

The following requirements can be summarized for proper functioning of the AF function:

○ a clearly defined subject
○ sufficient subject contrast
○ sufficient subject brightness
○ sufficient lens speed.

Lets first consider the lens speed. The Nikon AF lenses have a lens speed of at least f/4.5. The AF mechanism could not function for lens speeds slower than this, i.e. f/5.6 or f/8. This will not apply to AF lenses as they have been designed with these constraints in mind. But if you are using some other Nikon lens, which is quite likely as it is one of the advantages of the new AF-camera, you have to ensure that its maximum aperture is sufficient. If you wish to make use of the focusing aid in focus mode M, then this will not be possible with f/5.6 or slower lenses. The camera indicates this by the red warning cross that lights up in the viewfinder. It is still possible to use such a lens, but focusing has to be done, completely unaided on the focusing screen, as in the good old days.

Using an old Nikon lens with AF converter could also cause problems with insufficient lens speed. Automatic focusing will work for such lenses of f/2.8 or faster. It is possible to use a normal f/4 Nikon lens and make use of the AF focusing aid in focus mode M, but if this lens is attached via the AF Converter TC-16A, neither the automatic focusing nor the focusing-aid would be operable.

Dimly-lit subjects are also critical. But don't worry unduly. I was able to take successful shots with the F-501 with very dim subjects when it was even difficult to focus manually. Nikon have devised a sophisticated and highly sensitive AF-metering mechanism which allows reliable focusing, even with an 100-ISO film, and objects with an exposure value (EV) of only 3. EV 3 would correspond to a room of about 10 square metres or about 100 sq.ft., lit by a 60W to 100W tungsten ceiling light. But not only is the level of illumination important, the subject must also be lit uniformly. After all, the AF system only measures the centre part of the frame, and if the main subject

is hidden in a dark corner, even the highly sensitive AF mechanism cannot cope. The only solution in these situations is manual focusing. In emergencies you will have to judge the distance and make an approximate setting. If you are lucky enough to possess the AF flashgun SB-20, then you can use the infrared flash to focus.

Subjects with poor contrast are another source of problems for the automatic focusing facility. With contrast we mean that the subject has to have dark and bright areas and that these areas have clearly defined boundaries. Just try and focus on a smooth white wall. This will work only by pure accident. The autofocus will adjust the lens from close-up to infinity and then the red warning cross will tell you that it cannot focus. Another cause of problems will be a subject with a profusion of fine contrasty lines, for example, print on a newspaper. Whether this will work or not will depend on the reproduction scale. Horizontal lines are also not particularly favoured by the AF mechanism because its sensors are aligned to vertical structures. This really is not a problem though. Simply turn the camera into the vertical position; take the distance setting; keep the finger on the release button to hold it; re-align the camera for the required framing and take the picture.

Extreme back-lit subjects and excessively reflective surfaces could also cause problems because halation in the AF target field can reduce the contrast to an inadmissible degree. However this is rarely the case.

Lastly we have to consider subjects with confusing spatial relationships for the camera. By this I mean, for example, subjects that are staggered in space in a complicated array. Imagine two children, one standing behind the other. Part of the face of the farthest child and part of the nearer child are within the target field. Which child should the autofocus choose? In my experience so far I have found that the focusing system tends to choose the closer subject. This preference could be annoying if you try to take a shot through a fence, or the bars of a cage, where you do not want the sharp outlines of the wire. In such cases it will be necessary to ensure that the

important subject detail is placed within the target field, excluding the confusing foreground. With the focusing setting stored in focus mode S, the camera can then be re-aligned to take the shot for the required frame. Shooting in focus mode C would not allow the use of the focus lock button to store the correct setting. If this is unsuccessful, then there is always manual focusing.

I hope my description of unsuitable subjects for AF function will not make you doubt its usefulness and reliability. I deliberately set out to find subjects where the AF facility would have to admit defeat. I found it pretty difficult to find such a subject. The explanation is quite simple. The F-501's autofocusing depends on lighting and contrast conditions, but so does the human eye. After all, we can discern objects around us only if it is light enough and the details and outlines are sufficiently defined. My own experience has shown that the focusing limitations of the F-501 are approximately those of the human eye.

How Autofocus Works

I am including this chapter for the technologists. If you only want to use your F-501 to take pictures, and are not interested in what goes on inside the camera, then you can ignore these pages.

The AF mechanism of the F-501 consists of four modules. The first is the microcomputer in the lens. This conveys the typical characteristic values, such as lens speed (maximum aperture), focal length and focusing distance, via the AF contacts in the bayonet to the camera. Within the camera there is the AF distance metering unit. This consists of an image converter in CCD semiconductor technology with 2 x 48, that is 96 metering fields. One row of 48 metering fields is calibrated to apertures down to f/2.8, the other to f/4.5. Lens speed affects not only the brightness, but also the sharpness and this in turn the depth of field, this assignment of sensors increases

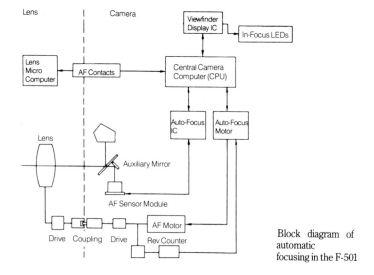

Lens | Camera

Viewfinder Display IC → In-Focus LEDs

Lens Micro Computer ← AF Contacts → Central Camera Computer (CPU)

Auto-Focus IC

Auto-Focus Motor

Lens

Auxiliary Mirror

AF Sensor Module

Drive Coupling Drive

AF Motor

Rev Counter

Block diagram of automatic focusing in the F-501

the metering exactness.

The metering signals from these CCD units are interpreted by a special integrated circuit (IC) and the result is passed to the central microcomputer (CPU) in the camera. The data supplied by the metering unit and those from the lens are combined in the CPU and converted into the appropriate command for focus setting. This instruction is conveyed to the AF motor servo unit. The AF motor drive IC converts this instruction into revolutions and triggers the motor to turn this exact number of revolutions in a forward or backward direction. A light barrier with an interrupt disc counts the motor revolutions and reports them back to the AF motor IC. The revolutions of the AF motor are transmitted via a gear train and coupling to the lens gear which performs the exact number of revolutions for distance setting on the lens. As soon as the lens setting is completed the CPU requests a further sharpness reading from the distance metering IC and then, if appropriate, passes the message "in-focus" to the IC in the viewfinder. Now the green in-focus LED in the viewfinder will

illuminate. Under ideal circumstances the whole process from measuring to completed focusing could take as little as $^1/_5$ second. If the distance metering IC reports incorrect focusing to the CPU after the lens has been adjusted, which could be the case in poor lighting conditions or for poorly defined subjects, then the focusing process is repeated by moving the lens through the distance settings from close-up to infinity. If this is still unsuccessful then the CPU reports to the viewfinder display by illuminating the red warning cross that focusing cannot be effected.

To understand how the electronic distance metering, or recognition of sharpness, functions in the F-501 we have first to define what sharpness is. A lens is set to the correct distance if every point of a subject for that distance is represented as a sharp point on the film plane in the camera. If the distance is not correctly set, then the point will no longer be sharply defined,

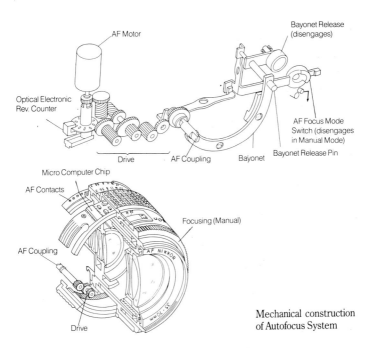

Mechanical construction of Autofocus System

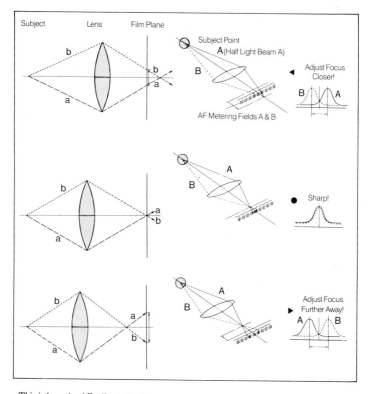

This is how the AF adjusts the focus.

it begins to get bigger and flow into other image points around it.

There are two instances of unsharpness. Setting for too close or setting for too far. For example, if the subject is 5m distant from the lens, but the lens is set at 2m, then the light beam of a certain subject point would combine in front of the film plane. To obtain sharp focus the lens would have to be turned in the direction of 5m (this is clockwise in the case of Nikon lenses) until the light beam combines exactly on the film plane. On the other hand if the object was 5m distant, but the lens was set to infinity, then the light beam would combine

behind the film plane. The lens now has to be turned in a counter-clockwise direction towards 5m. The distance metering mechanism in the AF system of the F-501 has the task of measuring and assessing the blurring of unsharp pictures, so that the direction in which the lens will have to be turned can be ascertained, and that the microcomputer in the camera can calculate the required distance the lens has to be turned in order to obtain correct focusing. To do this the sensor unit (CCD-Chip + evaluation IC) measures the expansion of the image point on the film plane due to incorrect focusing. To be precise, the measurement is not taken on the film plane: part of the light is allowed to pass through the partially translucent mirror and this is projected towards the CCD-chip, the length of the path for this portion of light is exactly the same as that to the film plane.

The trick employed by the AF system is that it consists of two types of metering fields. Type A and type B. A bevel-edged lens is placed in front of each of these measuring pairs, A and B, so that the light beam emitted from the subject point and passed through the lens is split and recombined at the metering points for each half of the lens. Let's consider the simplest case with the lens set to the correct focusing distance. In this case the light beam of the sharp image point is projected onto the AF sensor such that the two adjacent metering fields comprise practically the entire light beam. Metering field A receives the light from one half of the lens, metering field B receives the light from the other half. The evaluation electronic circuits in the focusing-IC compare the two measured curves of measuring points A and B. If the two curves coincide, or to use an electronics term: if the curves are in phase, then the focusing-IC reports to the microcomputer "image in focus".

Now consider the case when the lens is set too close and the unsharp image lies in front of the film plane. In this case the blurred image point in the AF sensor illuminates not just one measuring pair, but a whole sequence. As a consequence the two measuring curves A and B (to be precise the curves of A-

measuring field and B-measuring field) diverge at the maximum points.

The same occurs when the lens is set for too great a distance, the two measuring curves will also diverge, i.e. they are not in phase. But the direction of the divergence for "too close" is opposite to the direction for "too far" and the focusing-IC recognises immediately in what direction the lens has to be turned. This information is transferred to the central microcomputer in the camera, which, in turn, causes either the right- or the left-pointing arrow in the viewfinder to light up. The focusing IC also interprets by way of this "phase detection" how far the curves are offset or divergent from each other. This provides the measure for how far the lens has to be turned to obtain maximum sharpness. This information is also conveyed to the CPU, and the camera calculates from this information and the lens data the required lens settings.

Now I can also divulge why the AF sensor in the F-501 does not like subjects with horizontal structures. The measuring fields of the AF sensor are arranged as vertical strips, and these are best suited to interpret vertical variations in brightness. This is also the situation with the focusing flash of the AF flash SB-20.

Choice of Automatic Exposure Programs

From a technical point of view the F-501 is equipped with everything that a photographer may wish with regard to exposure programs. The required shooting mode can be freely selected. For example if one of the program modes are chosen, the camera's electronics will automatically select aperture and exposure time. Automatic program modes are not only useful for the snapshot photographer, they are useful too for anyone who likes to catch a quick, surprise shot. Then there is the aperture-priority mode A. In this program mode you preselect the aperture and the camera will choose the appropriate shutter speed. This program is therefore useful if you wish to influence the chosen settings to suit the subject. Situations when you will want to use this are when the depth of field is of importance, when you want to freeze a moving object, or when you want to emphasise its movement by a controlled blurring of the outlines. The ambitious photographer and purist can do it all manually by setting the aperture and shutter speed exactly according to their own judgement. How all this can be done will be explained in the next few chapters.

The Programs

In the program mode your camera will select the correct aperture and shutter speed, depending on the amount of light and the film speed. The only thing that the photographer has to do is to set the distance, i.e. bring the subject into sharp focus. This too will be done by the camera if you are working in focus mode S or C and have one of the AF lenses attached to your F-501. Quite justifiably, the program mode is also called the snapshot mode. Of course there are disadvantages. In this mode it is not possible to compose a picture with the appropriate depth of field. On the other hand it enables you to

take pictures which you might otherwise have missed because the opportunity would have been lost by the time you made the adjustments.

The F-501 does not offer you just one program mode, it offers three choices. The normal program mode P, the first program, is designed in such a way that you will be able to use it to best effect with the majority of subjects. The second program, P-HI, on the other hand selects larger apertures and therefore shorter exposure times. This is especially useful if you use longer lenses or are taking fast moving subjects, as the shorter exposure times reduces the danger of blur due to camera shake or subject movement. The third program P DUAL is, strictly speaking, not a separate program. Its effect is to switch automatically to program mode P-HI if you are using one of the modern Nikon lenses with focal lengths from 135mm or longer.

What you have to consider with program modes: After loading the film and setting the film speed (or DX indexing), select either program mode P, P-HI or P DUAL and select the smallest possible aperture, i.e. the largest number on the lens. The F-501 is now the perfect instrument for snapshot photography. If you use an AF-lens, S would be the best focus mode to use with the program modes. The viewfinder indicator shows the shutter speed which is calculated by the camera. If a second value flashes in the viewfinder, or if two flashing values are displayed, both of them flashing alternately, then this means that the calculated shutter speed lies between these two values. The values indicated in the viewfinder can only be in fixed increments, such as $1/60$ or $1/125$, but the camera is able to expose at intermediate values. For example at $1/80$, $1/90$ or $1/100$ second if one of these is the appropriate calculated time. Anyway, you need not concern yourself too much with what is indicated in the viewfinder. It is only important if you are concerned about overexposure, underexposure or the danger of camera shake.

Should you have forgotten to set the smallest aperture, i.e.

the largest f/number, then the underexposure and overexposure indicators both flash at the same time and the audible signal will sound, unless it has been switched off. If you have selected the smallest aperture and only the upper section of the indicator which warns of overexposure flashes, then this means that your subject is too light and that even with speed down to $1/2000$ second and the smallest possible aperture there is a danger of overexposure. If you loaded a colour print film you can usually continue to shoot as the print film is able to cope with overexposure of up to 2 stops, if the subject is not too high in contrast. However, if you are using slide film you will be well advised not to take any pictures. The only thing to do would be to load a slower film or to use a neutral density filter on your lens.

By the way, always make sure that the lens you are using is of the AI-S type. Nikon lenses of this type may be recognised by the smallest aperture (highest f/number) being coloured orange, otherwise the program modes will not work. Almost all modern Nikkor lenses are of this type. If you are using one of the exceptions such as shift lenses, mirror tele-lenses or fisheye lenses, you only need to change to aperture-priority (A) mode and you can then use them with the F-501.

As mentioned previously, the danger of camera shake is indicated by a bleeping sound for exposed times longer than $1/60$ second. If you are in program mode and such long exposure times are necessary then it might be better to switch to aperture-priority. It is necessary for you to take some action anyway and it may be sensible to select a smaller aperture for stationary subjects in order to obtain a greater depth of field. This should only be done provided you are working with a tripod.

Suitable films and lenses for each program: Before we think about which subjects are best suited to the program modes I would like to make some suggestions on the choice of films and lenses:

○ For the general program the most suitable films are the

medium speed ones of 100 and 200 ISO.
- ○ The most suitable lenses range from a 28mm wide-angle lens to the lighter-weight tele lenses up to 105mm. The appropriate zoom lenses within this range are of course also suitable.
- ○ The high-speed program is normally used with longer focal length lenses of up to 300mm. Generally the most suitable film is a 400 ISO, but also 1000 ISO and even 1600 ISO will be handy.
- ○ If working in P DUAL you should always use fast films if the focal length used is longer than 135mm.

Not only for snapshots: If the lighting conditions are reasonable, then you will always be able to use the program modes for street scenes, children, beach photos, etc. Although landscapes are usually properly exposed when you use the program mode, you could have problems with depth of field. If you want to produce a good picture of a landscape where everything has to be in focus for example, then you would be well advised to try f/16, rather than f/4. Let's say the prevailing lighting conditions are EV12. The normal program mode would select f/5.6 and expose at $^1/_{125}$ second. Now if you selected f/8 manually and used $^1/_{60}$ second, and provided you used a tripod, you would obtain a better picture. The high-speed program is totally unsuited for landscape photography. For such themes it is best to choose aperture priority (A), which allows you to preselect the suitable aperture and the camera will select the appropriate shutter speed.

Moving subjects, for example in sports photography, are generally not very well suited for the normal program mode. Furthermore you should bear in mind that tele-lenses with focal lengths of over 200mm greatly increase the danger of camera shake and hence blur. It is therefore advantageous to select P DUAL because in this shooting mode the camera will

The extreme 20mm wide-angle was best suited for capturing the atmosphere of this mine museum in Wales. Longer focal lengths would not have been able to get enough into the frame. *Photo: Wolf Huber*

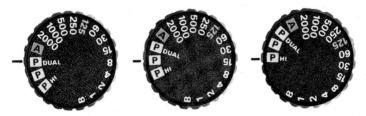

When shooting in program mode the exposure mode selector is generally best set to P DUAL. Aperture to highest f/number. The cameras will then automatically select the suitable program for the lens attached. If the focus mode selector is set to S, then you only need to release. Incorrectly exposed and out-of-focus and blurred pictures are practically impossible. P is selected if you need to work in the long-exposure program, for fast shutter speeds select P HI.

Viewfinder displays in the program modes: a set smallest aperture opening, i.e. largest number! (This warning symbol is not given for lenses without data transfer) **b** Exposure will be made at $1/125$ sec. **c** The exposure will be taken at a value between $1/60$ sec. and $1/125$ sec. **d** danger of over-exposure **e** danger of under-exposure.

automatically switch to high-speed program PHI for the long focal lengths. Perhaps you know the rule which says that the exposure time should be at least the reciprocal of the focal length. Thus for a 500mm lens one would need a speed of $1/500$

The extreme 18mm wide-angle is sometimes the ideal tool for impressive architectural shots. The secret of the stark impression of the view of the boats in the harbour was a rather short exposure to set the bright boats against the dark water. *Photo: Wolf Huber*

second in order to avoid camera shake. Combining a 200mm or a 300mm tele-lens with a 1000 ISO film would therefore give you a range of 12 to 21 EV for well-lit subjects and the high-speed program would be able to select shutter speeds between $^1/_{250}$ to $^1/_{2000}$ second for the chosen aperture values. The high speed program P-HI, or P DUAL, together with fast film is the best combination for sports photography. Using the program mode with focus mode S and with winder with focus mode C, then you have the ideal fast-shot automatic mode.

How program mode works: The program modes of the F-501 allow you to take pictures without having to spend a lot of time on deciding how. This is done by fully automatic adjustment of the aperture and exposure time according to film speed and lighting conditions. It is obvious that this facility is extremely useful for snapshots, but more ambitious photographers will be interested to explore the facilities of the program modes to the full.

The automatic program modes calculate the brightness of the subject and the light value appropriate to the selected film speed. This is then converted into an appropriate combination of exposure time and aperture. The program will select from all the possible exposure time/aperture combinations the one which corresponds best to the normal program or the high-speed program curve. These are represented by the program curves of the F-501. The time indicated in the viewfinder is the time in the exposure/aperture combination that the program has chosen. However, the aperture value is not displayed anywhere on the camera. If you do wish to know, keep the viewfinder pointed carefully at the subject and turn the aperture ring to select a larger aperture (smaller f/number). The aperture value selected by the program is then exactly that value after which the warning indicator for forgetting-to-stop-down-the-aperture flashes (both under- and over-exposure indicators flash). Normally you need not concern yourself with this value, the camera will automatically set the aperture to it before activating the shutter.

What happens if the aperture sticks, or if it is too loose? In such a situation the selected aperture would not agree with the calculated value and using the program mode would be a risky business. This problem has been solved rather well by Nikon. After depressing the shutter and after the aperture has been closed to the selected value, the actual subject brightness is re-measured at the last moment, just before the mirror is folded away, and this value is used for the final calculation of the shutter speed. The actual exposure will therefore correspond to the aperture/shutter speed combination of the program curve only in the ideal case. Only the final measurement of subject brightness at closed aperture, taken some milliseconds before actual exposure, serves for the final calculation and setting of the shutter speed. This has the

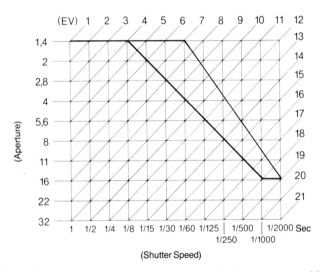

(Shutter Speed)

The F-501 program diagram shows what shutter speed and aperture are used for a certain exposure value. The line on the left shows the normal program (P) value and the line on the right the fast speed program (HPI). If you want to know the value of the aperture, follow the diagonal EV-line from its intersection with the program curve to the left to read the aperture value. To read the shutter speed follow the vertical line from the intersection down. Example: for an EV value of 12 and using program P the camera will use aperture f/5.6 and shutter speed $^1/_{125}$ sec, with PHI the aperture would be f/4 and the time $^1/_{250}$ sec.

advantage that, irrespective of any mechanical inaccuracy of the diaphragm mechanism and errors in transferring aperture data, the exposure should always be very accurate. Even in the extreme case where you have forgotten to close down the aperture and the program mode is unable to set the calculated aperture, the camera will still expose correctly. It will stop down the aperture as much as possible and the subsequent measurement will adjust the shutter speed to obtain the correct exposure level.

If you are working with zoom lenses, which have no uniform lens speed (e.g. the Nikkor 35-70mm f/3.3-4.5) you will encounter no problems with the program mode. If it has calculated the aperture as f/4 and the shutter speed as $1/250$ from the subject brightness and film speed, then the actual aperture value will be slightly larger or smaller, depending on the focal length selected on the zoom. This will have no effect on the correct exposure as the final measurement with closed aperture will cause the shutter speed to be lengthened or shortened as appropriate.

If we examine the diagram with the program curves we note that this is an exposure value/aperture/time curve. In order to interpret this it is necessary to understand what is meant by exposure value. Regardless of whether you use a Nikon or any other camera, you will find that most modern camera manufacturers use this term to define the measuring range and setting characteristics for their cameras. The exposure value (EV) is a quantity denoting a number of equivalent aperture/shutter speed combinations. Equivalent here means that these combinations will all produce the same effect with regard to exposure. Examples of aperture/shutter speed combinations are:-

EV8 Aperture	32	22	16	11	8	5.6	4	2.8	2	1.4
Time (sec)	4	2	1	$1/2$	$1/4$	$1/8$	$1/15$	$1/30$	$1/60$	$1/125$

EV12 Aperture	32	22	16	11	8	5.6	4	2.8	2	1.4
Time (sec)	$1/4$	$1/8$	$1/15$	$1/30$	$1/60$	$1/125$	$1/250$	$1/500$	$1/1000$	$1/2000$

EV17 Aperture	32	22	16	11	8
Time (sec)	$1/125$	$1/250$	$1/500$	$1/1000$	$1/2000$

A difference of one EV corresponds to a difference in exposure of one f/stop, or a doubling or halving of the exposure time as the case may be.

If we apply this now to the program curve we will observe the following. If the measurement of the subject brightness with film speed 100 ISO produces an exposure value of 7, which would probably be the case for an indoor photograph in a room lit by artificial light, then the high speed program would select an aperture of f/1.4 and provisionally choose a shutter speed of $1/60$ second. If the camera measures EV12, which might be the case for an outdoor picture with heavy cloud cover and using an 100 ISO film, the camera would select in normal program mode f/4 and speed $1/250$ second from the series of possible combinations. If the measurement produces an exposure value of EV 17, for example an outdoor situation with cloudless sky, bright sunshine and an 400 ISO film, then the high-speed program would always select aperture f/11 and shutter speed $1/1000$ second.

Using the example of the normal program that the subject brightness should be such, that with 50 ISO film the camera measures EV6, the program will automatically expose with aperture f/2 and $1/15$ second. If we now load a 400 ISO film and the subject brightness remains the same, the camera will measure EV9. The normal program will now expose with aperture f/2.8-f/4 and the shutter speed will be reduced to $1/45$ second.

The limits of program mode: Let us have a closer look at the normal program P. We find that if we are using a lens with speed f/1.4 it will behave like an aperture-priority program for calculated exposure values EV1 (aperture f/1.4 and 2 seconds) to EV4 (aperture about f/1.4 and $1/8$ second). In the case of the high-speed program PHI this range is extended even to EV7 (aperture f/1.4 and $1/60$ second). The program curve starts

close to that aperture/shutter speed combination which the F-501 is still able to realise with the darkest subject and the most sensitive film of 3200 ISO. The curve will be extended as a straight line to the left for slower films to include longer shutter speeds approximately to EV9 (aperture f/1.4 and 14 seconds).

As mentioned previously, the program mode re-checks the brightness levels for the chosen aperture. This means that after the aperture is closed to the value calculated by the program, the subject brightness is measured again and the actual valid exposure time is calculated and automatically selected. The actual speed of the shutter is thus perhaps a little longer or shorter. The program curves therefore are somewhat more flexible than shown. To be precise, the program modes are shutter speed priority modes with subsequent aperture priority mode. However, as the aperture-priority has the real priority, the F-501 actually attains great accuracy in the program modes and is very reliable in producing the correct exposure levels.

From EV19 the programs become by necessity shutter-speed priority programs. The shutter speed cannot be reduced beyond $1/2000$ second and the program can only reduce the aperture at a fixed shutter speed. Nikon does not provide any graphs for these cases, but I have checked them by my own tests using lenses with aperture settings of f/22 and f/32 respectively. The fact that Nikon has not included this range in their documentation is understandable, as the precision of the exposure can no longer be guaranteed in this range. The deviations in the aperture value settings can now only be compensated for by the final measurement if the deviation is towards longer exposure times. If the limit of your setting range is reached, any amount of re-measuring will have no effect.

The program curve is based on a lens with a speed of f/1.4. What happens if you are using a lens the largest aperture of which is only f/2.8? For an exposure value of EV6, for example, the high speed program can no longer select f/1.4 and $1/30$

second. In this case the aperture stays fully open at f/2.8 and the program will, after final measurement, adjust the shutter speed to $^1/_8$ second, which will produce the correct exposure level. The actual range of the high-speed program for a lens with a speed of f/2.8 maximum aperture therefore does not start with exposure value 4 (about f/1.4 and $^1/_{60}$ second) but only at EV10 - 11 (f/2.8 and about $^1/_{180}$ second).

It is pointless to use lenses with a fixed aperture, such as a mirror lens, or those which do not allow data transfer. Very long lenses are not particularly well suited to the program modes either. It helps to use faster films so that for the larger exposure values you will be able to obtain quite reasonable times with the high speed program.

What happens if it is too light and the EV goes beyond 20 because of the high lighting level and a fast film? In principle exactly the same as for aperture priority; the exposure time adjustment has reached its limit. This would be the case for lenses with a smallest aperture of f/16. The F-501 is not able to produce a smaller EV than aperture f/16 and speed $^1/_{2000}$ second. But as we have said before, for lenses which may be stopped down to f/22 or even f/32 the automatic range goes that much further. However, such large exposure values are very rare with medium and slow speed films. In extreme cases you could use a neutral density filter or perhaps use a slower film.

All-round Aperture Priority Mode

If you set the exposure mode selector dial to A, then the camera will work in the aperture priority mode. For each manually selected aperture the camera will automatically calculate the appropriate shutter speed. Considering its technical possibilities, aperture priority is a real universal automatic program mode. Regardless of which focal length your lens is, whether it is capable of data transfer or not, you can use this program mode for almost any situation: landscape,

portraits, architecture, macro, ... In many situations this mode is not only the best but also the only possibility. Depending on the situation and subject, you will now and then have to apply a little expertise, but that does not mean that you can't use this mode for snapshots.

What you have to consider with aperture priority mode: Load the film; select film speed or DX indexing; set exposure mode selector dial to "A"; and that's it. Now you only need to focus and select the aperture according to your wishes and the prevailing lighting conditions.

In mode A you will see in the viewfinder only the shutter speed that the camera has calculated for the aperture that you have selected. Shutter speeds of over 1 second, which could be necessary for slow films, will be indicated by the underexposure symbol. Possible overexposure is also shown by the overexposure symbol. You have to stop down at least until the shortest shutter speed of $1/2000$ second appears again without flashing in the viewfinder. If it is not possible to stop down any further, then use a neutral density filter. The amount by which the light is reduced is indicated on the edge of the filter. An inscription +1 means that the brightness is reduced

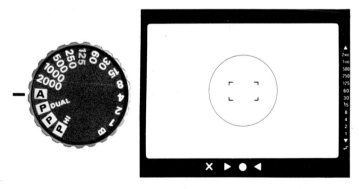

For aperture priority you have to set the exposure mode selector to "A". You are then able to pre-select the aperture for every exposure.The viewfinder display will be the same as for the program modes.

by an amount equivalent to stopping down by one stop. Alternatively it may be expressed as a factor for increase in the exposure time. If your filter is inscribed with x2, this means that the exposure time has to be doubled. Some manufacturers of filters state the value of the filter in photographic density values. In that case the legend ND 0.30 means that light is reduced by a full stop, ND 0.10 a third of a stop and ND 0.60 two stops. If you are unsure you can always check the effect of your filter by the indicator in your viewfinder; this will show whether you are within the range of your lens or not.

Large apertures for portraits, small apertures for landscapes!: It makes no difference to the exposure level if you use apertures f/4 or f/16 in aperture-priority mode. If your camera selects $^1/_{1000}$ second for f/4, it will, under the same conditions, select $^1/_{60}$ second for f/16. The amount of light, and therefore the exposure level, will be the same in both cases. Apart from the relatively long exposure times which could result in camera shake, and perhaps failure of the reciprocity law, any time/aperture combination producing an equivalent exposure level is as good as any other.

This argument applies only to exposure level. In sports photography, for example, it is important to use short exposure times, whilst in the case of portraits the correct use of the aperture is important. Whether you wish to freeze a fast movement, or intend to show speed by blurred speed lines; whether you want to produce a portrait against a sharp background or prefer a blurred background; for each picture there will be the ideal shutter speed/aperture combination producing the image you saw in you mind's eye. No program can make the decision on which aperture to use. Even the high speed program will only select the correct shutter speed for the pre-selected aperture. The photographer therefore has only two possible choices; he can select a certain aperture and the program will choose a time to complement it, which he can check on the indicator panel to insure against camera shake, or

he can turn the aperture ring until the required time is indicated in the viewfinder. Let us consider the aperture first.

Great depth of field is not always desirable: The optimum aperture depends on the one hand on the subject, and on the other, how you wish to treat it. Your ideas of how to present a scene can be totally subjective. If you wish to produce very sharp images, as for example in architectural photography, where every detail needs to be clearly reproduced, then you have to work with the aperture at which the lens produces its best results. Lens aberrations are an optical reality; they may be corrected but can never be removed completely. Theory says that the optical output of a lens is worst when the aperture is fully open because of spherical and chromatic aberrations, astigmatism, etc. Stopping down to the medium aperture values will produce the best reproduction results. If you stop down even further there will again be a decline in the quality due to increasing diffraction effects. Practical application and many lens tests have proved that the optimal lens output lies between f/5.6 and f/11. An aperture of f/8 or f/8-11 must therefore be considered the best advice if you are after fine details across the whole image. In the case of telephoto lenses larger aperture values may also be included.

Apart from definition, the aperture setting plays a major role in determining the depth of field. You may already know that it is impossible to represent a spatial object uniformly sharp from distance zero to infinity. Only a few objects are two dimensional, most contain spatial elements, so only a certain range of their depth can be represented in sharp focus. Looking from the camera's viewpoint the depth of field is from the least distance to the greatest distance within which the object is represented in acceptably sharp focus.

The human eye has no such problems. You should therefore never rely on your own visual impression when determining the depth of field of a shot. Focusing in the human eye is performed by the visual centre in the brain and is always

adjusted to the area or point on which you are concentrating. As this is done without your being aware, you always have the impression that everything you see is always in perfect focus. When looking through your reflex camera, however, you are focusing on a certain point in the viewfinder and the depth of field comprises a limited range in front and behind your focusing point. How great this range is depends on the distance of your focal point, on the aperture and on the focal length of your lens.

As a general rule you should remember: long distance, small aperture (= large f/number) and short focal length result in great depth of field. It will prove helpful if you can remember a few general values for your guidance. Using a lens with focal length 50mm and focusing on a subject at 0.5m distance, the depth of field will be 0.49m to 0.54m. If you focus on a subject at 3m, the depth of field will be from 2.2m to 5.2m. When focusing on a subject at 22m distance, the depth of field will stretch from 6m to infinity. If you focus on infinity when using aperture f/8, the depth of field will extend from about 9m from the lens to infinity. These examples show clearly that the shorter the distance, the smaller the depth of field. In addition you have to consider that it will extend further behind the focal point than in front of it, leaving macro photography out of account.

For the middle range the general rule is twice as far behind the focal point than towards the camera – one third in front, two thirds behind. The aperture setting also has a great effect on depth of field. In the case of a 50mm lens, focusing on a subject at 3m distance from the camera and with an aperture setting of f/1.2, the depth of field would be from 2.88m to 3.14m. If an aperture setting of f/5.6 is chosen, the depth of field is increased from 2.5m to 3.7m, and if the aperture is f/22, the depth of field is even deeper, from 1.6m to 15m. As you can see, the depth of field increases with smaller apertures. For a distance setting of 5m, the depth of field range with aperture f/16 would be from 2.6m to 112m, and with aperture f/22 from as close as 2m to infinity. You should make use of these

characteristics. If your point of focus is determined by your image frame and camera position, then you can determine the depth of field by choosing a larger or smaller aperture setting. If you take architectural shots where every detail is important, you will stop down to the smaller apertures, but in portrait photography, where a detailed background is only distracting, you would choose the large apertures to concentrate solely on the essentials.

One general rule is often used. Short focal length is equal to great depth of field. But this is only true if you assume a fixed camera position for the shot. Let's take, for example, a focusing distance of 4m and aperture f/8. Using a 16mm lens the depth of field will stretch from 0.8m to infinity. With a 28mm lens, it ranges from 1.8m to infinity, but if we take a 50mm lens, the range is reduced from 2.9 to 8m. As we have used the same camera location in our example, i.e. the same distance to the object, we find that with increasing focal length the reproduction scale becomes larger.

Now let's look at the other case where we photograph the very same object, using lenses with different focal lengths and with different camera positions, in such a way that for each focal length the subject is represented to the same scale. Although a short focus lens gives more depth of field than a long focus lens, bringing the camera nearer to the subject to maintain the same image size for the principal object, cancels out this advantage.

It is sometimes stated that if we maintain the same image/object ratio by altering the lens-to-subject distance, then depth of field is independent of focal length for the same f/number. This, however, is true only under certain conditions. It is true for image/object ratios from 1/1 to about 1/10 but for larger I/O ratios the advantage is always with the short focus lens especially at small lens apertures.

Let's summarise the different rules on depth of field for practical application:
○ The greatest possible depth of field is obtained by exact focusing on the important feature in the subject and by

stopping down the aperture.

○ If you wish to show only a certain part of your image in sharp focus, then you have to focus exactly on the required distance and select a relatively large aperture.

○ If only the foreground up to the important feature is wanted in sharp focus, then you have to move the point of focus closer to the camera, and to stop down just enough so that your important feature is only just in focus. This means if you use focus mode S you have to focus on a subject detail closer to the camera, store the focusing setting, realign the frame and then release.

○ If the foreground needs to be somewhat out of focus and the important feature is in the background, then you have to relocate the point of focus, just beyond the required feature, and stop down as much as necessary to just bring it into focus.

The depth of field scale is an important aid for picture composition: such a scale may be found on every lens. It will indicate the depth of field from the nearest to the furthest distances for the appropriate aperture. However, these scales are not always very precise and they can be difficult to read. If you need to know exactly, you will need a depth of field table. I have included some tables which have been compiled by Nikon for some of their lenses. If you are in doubt, you may refer to these tables. It is also a good idea to browse through them to get a better idea of depth of field distances. It will give you a feeling for the subject, and in any case it will be cheaper than wasting a lot of good film and good opportunities.

Fast shutter speeds for Football: When you want to capture moments in a race, in a football or ice hockey match, or wild animals at large, the exposure times for moving subjects can never be too short. On the one hand the subject's movements could blur the image, and on the other there is the increased likelihood of distortion due to the larger apertures than are usually necessary in these circumstances. Both of

these occurrences are often referred to, somewhat incorrectly, as camera shake. Here it is worth repeating the golden rule for the photographer to guard against camera shake, i.e. unsteadiness of the camera. The shutter speed should be equal to or faster than the reciprocal of the focal length of the lens in mm. According to this rule, a shutter speed of about $1/30$ second would be sufficient for a 28mm wide-angle lens; for a 50mm lens it would need to be $1/60$ second, and for a 500mm telephoto you should use at least $1/500$ second. You may think you have depressed the release ever so softly, but if you are using a long lens, the slightest movement of the camera will result in a slight swaying of the lens, which in turn will cause your image to be blurred and your efforts to be spoilt. A tripod and a cable release, or an electric remote release would be the solution in such cases.

By the way, for all shots where you do not have your eye behind the eyepiece, it is essential that it is protected by the eyepiece cover. If this is not done, light could enter through the eyepiece and cause the light meter to make a false measurement because it would see the subject as brighter than it is.

Now you may think that the motor would cause movement in the camera when using the remote release. This is true to a certain extent, but as the vibrations are only caused after the exposure has been made, it does not matter at all, as long as we are only taking single shots. For continuous shots it could cause difficulties.

It is of course true that we encounter situations where we have to take hand-held shots. In that case an appropriately fast shutter speed has to be used, especially when using telephoto lenses. The same applies for fast subjects and small apertures. For normal and short focal lengths you should make use of a well-tried formula: with $1/15$ second you appear to shake more than with 1 second. If you have a steady hand than you could say that you will shake perhaps only in one direction when you are using $1/15$ second, but for 1 second you will move a few times across the picture axis. In the first case your print will be

somewhat smudged, in the second you will produce a hard core image around which are shown uniformly blurred outlines.

Don't forget to make full use of automatic focusing when taking shots of fast moving objects as I have already described.

Making speed visible: Generally speaking, long exposure times and moving subjects don't go together. A racing car that has become a long coloured streak because the exposure was too long, is more likely to end up in the wastepaper basket than in a journal of photography. On the other hand, it is not always correct to freeze a movement totally on film. The petrified gymnast may be of some interest to the trainer, but most of us would not find such a representation very aesthetically pleasing. The art is to expose fast subjects in such a way that they are still sharp, without depriving them of any movement. This obviously means choosing the right exposure time. If you have tried in the past and it did not turn out exactly to your liking, let me assure you that even experienced sports photographers produce over 90% rubbish!

Still, you cannot rely entirely on good luck and happy coincidence. You could achieve your desired results by using up a lot of film, but it would be cheaper and less frustrating to bear a few helpful numbers in mind. It is possible to calculate in advance at what shutter speed a moving subject starts to become blurred. You will find a table below of popular subjects and blurring of movement.

Now, if you wish to make the movement visible, you have to expose for longer than the given times. You first estimate the speed of the subject, then adjust the aperture so that the shutter speed is just within the given range.

By the way, movement of an object can be demonstrated very easily to the viewer by showing it sharply against a blurred background. You achieve such results by panning in the direction of the movement. This too will take some practice and you will probably have to sacrifice a few films before you get the hang of it.

Blurring due to Movement

Distance from Camera to subject	Direction of Movement to film plane		
	↕	✕	↔
Slow movement, pedestrians, children at play, cars moving at up to 15 m.p.h.			
4m	1/125	1/250	1/500
8m	1/60	1/125	1/250
16m	1/30	1/60	1/125
Fast movement, runner, fast sports, vehicles moving at up to 30 m.p.h.			
4m	1/500	1/1000	2000 or panning
8m	1/250	1/500	1/1000
16m	1/125	1/250	1/500
Very fast movement, vehicles at about 60 m.p.h. or over			
4m	1/500	1/1000	1/2000 or panning
8m	1/250	1/500	1/1000
16m	1/125	1/250	1/500

If you wish to represent movement by a certain amount of blurring, then it is relatively easy in the aperture-priority mode. First you focus on a point which the subject will shortly cross. If this is difficult by autofocus then it will have to be done manually. Then preselect the aperture which gives you the desired shutter speed in the viewfinder. It is important that you direct your viewfinder at an object that corresponds more or less to the brightness of whatever you are actually going to photograph. If that is difficult then you can select the exposure

A promenade shortly before sunset. Aperture priority and centre-weighted metering produced the correct exposure more or less by accident. If the metering had been taken for the lights, the total exposure would have been too dark, metering on the dark beach below would have resulted in too bright an image. Metering for the centre of the frame produced the correct balance.

values manually. This has the advantage that all pictures for which you have determined the correct combination of aperture and shutter speed to produce the desired blurring effect taken under the same lighting conditions will always turn out the same.

Long exposures in available light: The F-501 is ideally suited for lengthy exposures in the aperture priority mode. The program modes are not suitable, as you have to take an active part in producing the shot in order to avoid the very real danger of camera shake with long exposures. In any case you would be working within that range which enters the aperture priority mode, as you have to open the aperture wide under low lighting conditions. When using aperture priority mode you are still free to make your choice, even in dimly-lit conditions. Under certain circumstances if you are taking stationary subjects it could be advantageous to stop the aperture down again to increase depth of field. This would also prevent some optical distortions which are inevitable for larger apertures and which manifest themselves, in particular in night photography.

For lengthy exposures, whether at night in the open air, in a dark cathedral, or secretly in a museum, I would recommend a 400 ISO daylight film. The 640 ISO artificial light film may be suitable for situations lit solely by tungsten light. Personally I would use an 1000 or an 1600 ISO film only if this avoided the necessity to expose with shutter speeds longer than $1/60$ second. Therefore I usually choose a 400 ISO film whenever the situation requires the use of a tripod. The 400 ISO films are preferable to the very fast films for their finer grain, better resolution and better colour reproduction.

Whenever you are working with a tripod, or are supporting the camera in some other way, you should always use the self-

Ravages of time and the elements leave their mark on the once splendid West Pier in Brighton. The ideal position for the photographer with the lens axis exactly perpendicular to the picture axis. Despite the wide-angle – no converging lines.

timer for long exposures. This prevents camera shake when depressing the release. The electrical remote release of course is also suitable, but don't forget the eyepiece cover.

Long exposures would therefore not be any problem if the reciprocity effect for daylight colour print film did not make itself felt from about $1/10$ second. In other words, the effective film sensitivity declines with long exposure times. It may be necessary to overexpose by up to two stops to compensate, but this depends on the type and make of film used, and on the range of exposure times.

In the case of night photography and similar available-light photography, personal preferences always play a considerable role, and therefore you have to decide for yourself how much you wish to compensate. You could take one exposure without correction, then take additional ones with correction factors + $2/3$, +1, +$1^1/3$. If you are specialising in long-exposure photography you will soon develop the necessary feel and produce the desired result at the first go.

Working aperture mode for all events: When the F-501 is in aperture-priority mode (A), and the information regarding aperture and lens speed is absent, it will always function in working aperture mode. This is useful for all lenses, adapters, bellows devices, slide copying accessories etc., and also for the use of lenses with different screw fittings or bayonet fittings, as these often do not allow data transfer. The exactness of exposure should not be adversely influenced by the working aperture mode.

Let's assume that you are using a telephoto lens with 300m focal length and a so-called T-adapter. If this lens has a speed of f/5.6 you can open the aperture completely when you set the focus. Before you actually release the shutter, you have to remember to reset the aperture you had decided to use. This is contrary to practice with the lens alone which has a sprung diaphragm and will immediately stop down to its working aperture. You can recognise this by the fact that the image in the viewfinder becomes darker when you are selecting the

smaller apertures. The only disadvantage of the working aperture mode is the slightly more cumbersome operation and therefore slower handling. It is always necessary to open up the aperture to focus and then to stop down again for your light reading and taking the shot. This is a disadvantage if your subject is not prepared to wait. Of course the AF facility will also be inoperative in these circumstances

How aperture priority works: The exposure mode of most general use is the aperture-priority mode A. The versatility of the system is due to its technology. The exposure sequence is as follows: after the measuring sensors and the viewfinder indicator have been activated by slightly depressing the shutter release button, you see in the viewfinder the exposure time which has been calculated by the camera for your manually selected aperture. For this purpose the camera's processor measures the brightness of the subject by centre-weighted integral metering. Like most modern reflex cameras the F-501 works by open-aperture measurement, and for this calculation it uses the mechanically simulated value of the working aperture.

If you are stopping-down the aperture to, say, f/16 on the setting ring, in reality it will stay open and only the aperture data-transfer lever will pass on the information "aperture 16" to the camera's processor. Only when you depress the shutter release button will the diaphragm be stopped down to the preselected value via the auto diaphragm mechanism. The actual exposure value will then be re-measured at working aperture and the camera's processor will then effect the final valid shutter speed. Finally the mirror springs up and the shutter blinds open. Therefore any mechanical errors or inaccuracies in the aperture are of no consequence to the exposure level. The facility of final measurement is not only employed in the program modes of the F-501, it is also fully operable in working aperture mode.

What are the advantages of aperture priority? As mentioned previously, all modern 35mm reflex cameras are fitted with a

focal plane shutter. For optical reasons, namely that it does not act as the aperture, it has to be situated as close as possible to the film plane. For this reason it is always an integral part of the camera. Therefore the shutter is always the same, regardless of which lens you are using. The same is not true for the diaphragm, which also for optical reasons is always as close as possible to the centre of the lens. The accuracy of the aperture value, i.e. the agreement between the set value and the actual value, will vary from lens to lens. The mechanical tolerances of the diaphragm will also be greater than those of the shutter. What, you may ask, is the point of having the highest possible accuracy in exposure measurement and the setting of the aperture that is achieved for shutter priority systems, if it is lost again in the process of electro-mechanical and mechanical transfer? With this reasoning in mind there are obvious advantages to be found in the aperture-priority mode, which for this reason is also employed in the F-501 for its program modes.

Not only that, but the construction of the lenses, whether they are zoom or specially long tele, mirror-tele, shift or special macro ones, matters in no way with regard to the functioning of the aperture-priority mode. It even works with lenses that have additional gadgets added on, where no data transfer from the aperture is possible; namely in working aperture mode.

On the other hand, if you are using shutter speed priority mode, certain features will be excluded. Just think of genuine macro photography where you would have to perform laborious extension calculations. Adapters, bellows focusing devices, slide duplicators, lenses with fixed apertures, all are useless in the shutter speed priority mode.

The advantages of the aperture-priority mode are not only to be found in its technology. The only situation where shutter speed priority might be preferable is when you are photographing moving objects, for example in sports photography. Under these circumstances it could be of real advantage if the shutter priority sets the correct aperture for

92

the preset shutter speed. But I have already described how you can achieve successful sports photography in the program mode or in the high-speed program mode. I shall describe later on in this book how you can also achieve this by manual setting of the exposure. Apart from this situation, one can generally say that whether taking moving or stationary subjects, whether snapshot or arranged photograph, if you are using aperture priority you can never go wrong.

Using the automatic exposure lock: Automatic exposure does not always produce the best results. Exposure corrections can be cumbersome and there is the danger with the F-501 that you forget the set correction. It is faster and more convenient to use the automatic exposure lock. When you are in aperture-priority mode (A), point your camera at your subject so that it extends over at least the measuring area, or even better, over the whole frame, then depress the automatic exposure lock button and keep it depressed. The calculated shutter speed, which was also indicated in the viewfinder, will be stored in the memory. You are now free to re-position the frame, keeping the automatic exposure lock button depressed, and then fully depress the shutter release button. The exposure will be taken at the stored value. Apart from the inconvenience of having to keep your finger on the button, this is an excellent method for achieving correctly exposed pictures.

However the method is not suitable if the reflectivity of the

In aperture priority mode A and exposure meter lock you are able to expose exactly for the important detail. Aim at the subject with measuring field (12mm central circle) covering the important section) and depress exposure lock button and keep depressed until the camera has been aligned to the final frame, then release.

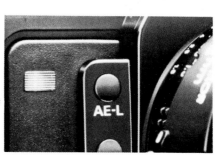

main subject does not correspond to the average grey. If you want to take a picture of a snowman in a white field, or the chimney sweep in the cellar, you will have to go back to exposure compensation.

The automatic exposure lock (AEL) is also useful in the program modes. It is less useful, regardless of which exposure mode is chosen, if a zoom lens with great variation in speed is used. In this case the use of the AEL may make matters worse instead of better.

Manual Mode for Experts and Perfectionists

In the manual mode you are able to expose exactly as you want. The pre-conditions are the correct choice of the measuring area, and the correct assessment of the measured value obtained by you, the photographer. In the manual mode all this is left to you. Not only will you have to be familiar with your camera's measuring characteristics, you will also have to know what correction criteria need to be applied to the measured value for a given subject. However, once you have mastered manual exposure, in many cases you will be able to achieve better results than any automatic!

How you use manual exposure settings: If you set the shooting mode selector dial to a value between $1/2000$ second and B, then your F-501 will be working in manual mode. You have to ensure that the film speed setting is correct. The exposure correction ring should generally be set to zero. If the aperture is not set to the correct value you will see at least two values in the viewfinder, one will be the manually selected shutter speed and there will also be an additional one or two flashing. The flashing value is the one that the exposure meter has calculated for the aperture which is set.

To achieve the correct result you keep the subject in the viewfinder, and adjust the aperture or the shutter speed

manually, until only one, non-flashing value is displayed. Let's assume you selected $^1/_{125}$ second and aperture f/8. On metering your subject the additional value of $^1/_{500}$ flashes in the viewfinder. You have the choice of leaving the aperture at f/8 and adjusting the shutter speed to $^1/_{500}$ second, or you may leave the shutter speed at $^1/_{125}$ second and stop down to f/16 instead. You could also adjust both settings, in this case by setting the aperture to f/11 and the shutter speed to $^1/_{250}$.

The 12mm metering circle indicated in the viewfinder will help you as a measuring aid. The F-501's light metering is weighted to measure 60% of the frame brightness within this 12mm metering circle. Now, if you are taking very contrasty subjects, for example an object against the sun or a very bright object in front of a dark background, then this measurement will be insufficient. You will have to move close to the subject, to cover as much as is possible of the whole frame, and then take your light reading. Using these stored values you can select the frame as you wish, the exposure will stay the same.

Every subject individually exposed: The manual mode of the F-501 should not present you with any particular problems. But how should you take your light reading and what correction factors should you apply? Metering the subject for its average grey, that is average brightness, would be the simplest. Whether the subject is uniformly bright or very contrasty does not matter, as long as you find the average point. You simply aim your camera at that point, set the time and aperture to the

If you select a shutter speed the F-501 will switch to manual exposure adjustment. The set shutter speed will be shown in the viewfinder, together with a flashing value which is the calculated required value. You have to adjust the aperture, or the shutter speed, or both until only one value is shown. Exposure will then be correct.

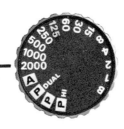

What are the preparations in aid of that these Bolivean Indians are so intent on? A religious festival, some pagan rites? The surreal mood has been perfectly captured by the photographer. Photo: Rudolf Dietrich

values which result in a balanced indication in the viewfinder. Thereafter you can chose the frame that suits you, the exposure is already electronically stored, and you can take your picture. If you wish to take the measurement at a point lighter or darker than the average grey value, then you can make the appropriate exposure correction. In many cases it is quite impossible to locate such an average grey value, so what should you do then? Also you may not be sure what brightness point corresponds to what subject point. Good advice such as "meter those areas of shade or light where there are still clearly discernible contrasts" is often less than helpful.

There is one very good metering point found on one of the most common subjects – the face. In summer, for beach photos, the tonal quality of the average European's complexion corresponds closely to the average grey. Therefore if you are taking a picture against the sun you can meter the face across the entire viewfinder and then recompose your frame and you will be more often right than wrong. Very light complexion,

which is also supposed to appear light in the picture, has to be taken with an exposure correction of $+ \frac{2}{3}$. Dark complexion needs an exposure correction of up to $-\frac{2}{3}$ to give a lifelike representation.

In many cases the use of a grey card, generally available in the shops, would be very useful. You put this card, which has a reflectance of 18%, within the subject field and you then have an ideal metering area. However, it could be that your subject is not lit very uniformly, parts lying in very dark shade whilst the rest might be in direct sunlight. Under such circumstances you have to place the grey card within that section of your subject which contains the important detail. If you want to represent average grey a little lighter or a little darker, then you will have to make the appropriate corrections. However, do not forget to reset the correction ring back to zero. With all its various audible and visible alarms, this is one case where the F-501 will leave you in the dark!

If your main subject is black, and you do not want it to be represented as an average grey, then you will be best advised to use manual mode. You simply meter the black area by metering the whole frame and use the resultant values with a correction value of -2 and the black will be shown black on your picture. In the same way you will have to make corrections for objects which are mainly white and need to be shown white in your photograph. As a rule in this case you can use a correction factor of up to $+ 2$ EV.

The correction values are of course different for each subject and the F-501 is capable of very fine adjustment. Every time you have taken a difficult subject successfully you know you are on the way to mastering this problem.

However it is easy enough to overdo it. Please don't make the mistake many novices do and mess around with the exposure correction on your F-501, just because it has got this facility. Manual exposure settings and exposure correction are one thing, but twiddling with the correction ring for no good reason is quite pointless. What's the point of having expensive equipment if you could take just as bad or even better pictures

with any kind of automatic, without any corrections?

But if you learn to meter difficult subjects correctly, be it on average brightness, face, skin, grey-card, or on black and white, then the manual mode, using exposure correction if appropriate, is surely the best method. The only other way to achieve similar good results is by aperture-priority and exposure lock.

Manual exposure for fast subjects: You won't believe me when I say that, as cumbersome as the manual setting might appear to be, sometimes it can be the best method for fast shots. If you are using the shooting sequence of pointing the camera, metering, possible exposure correction and then releasing the shutter when you are trying to catch a foul against

The recipe for this shot was to pan the camera with a telephoto lens, exposure time $^1/_{500}$ sec.

your favourite football team, then you will definitely be too slow! In that case the automatic exposure mode is the best bet. But there are moving objects which are not particularly suitable for automatic exposure. Just think about footballers in white shorts on a green field. Depending on how much white is concentrated on your particular frame, or in the centre metering zone respectively, you will have under- or overexposure, or perhaps you are lucky and the exposure turned out right. For this reason professional photographers always use a preset exposure setting for difficult subjects which are not easy to handle in the automatic mode. To do this you first measure the face of one of the footballers as close as possible. The values you obtain in this way for the aperture and shutter speed should be correct for the whole game, unless, of course, the lighting conditions change.

Faster than Autofocus?

When autofocus lenses and cameras first made their appearance, many professional photographers using the 35mm format smiled condescendingly at this new-fangled facility, which admittedly was not very fast or efficient in its early stages of development.

Modern autofocus systems like that of the F-501 are accurate and fast. Even the most skilled photographer has no chance whatever of focusing on a given subject in a small fraction of a second. Neither has he much hope of keeping in focus a moving subject as can be done so easily with the F-501.

I shall show you how you can use this trick very effectively with your F-501. You will need an AF lens with sufficiently long focal length or a normal, fast telephoto lens, better than f/4.5.

Use a 400 ISO film, or better still a 1600 ISO. Set the camera to manual exposure mode M and the focus mode also to M (AF focus assist). Set the exposure as described in the chapter about manual exposure for fast subjects. According to the lighting conditions, it should be as short a shutter speed as

possible and a reasonably large aperture. Now choose a distance setting on the AF lens that brings the point of the anticipated event into sharp focus. Now you are ready to release the shutter at any time. If the event takes place at the anticipated location, the pictures will almost always be in sharp focus. So far there is nothing different from what I had described before, but the focus-assist facility of the F-501 should give you that extra assurance.

Look through the viewfinder and, if the event takes place in the centre of the viewfinder, the green LED will light up to indicate that it is in sharp focus. If you take the picture with the green in-focus LED on, then you are guaranteed perfectly sharp pictures. In automatic focusing the focusing metering and indication is exceedingly fast. What takes the time is the motorized focusing of the lens. You need not wait for this with the method described, but allow the moving subject to come into focus, at which point you release the shutter. I wonder if any professional photographer has thought of that?

When Automation Fails to Work

There now follows a few chapters for perfectionists who want to exploit the capabilities of the automatic modes and the manual mode to their full extent. Some aspects which have been touched on in the previous chapters will now be fully explained. Is this necessary when it is so easy nowadays to obtain correct exposure? One only has to point the camera at the subject, the light meter takes the reading, and the automatic exposure mode selects the correct exposure. It is true that using these facilities only a few really badly-exposed pictures are likely to be taken. But what a disappointment when you could have taken an exceptional picture and it turns out to be satisfactory but by no means great. Let us be honest; we can see that many good pictures could have been improved when we examine them more closely, perhaps with some correction to the exposure; i.e. it may have been more effective

if the subject were a little lighter or darker. It does no harm to be a little ambitious. You should always try to do your best. Every subject should be correctly exposed, particularly as modern technology has put it all into our hands. I therefore assume that the majority of my readers aspire to a little more than the occasional snapshot. But if you want to improve your skills you will need to know how.

Beware of very contrasty subjects! As well as accurate rendition of colour, the film has to reproduce as closely as possible the nuances of light and shade. This can be described as correct tone rendition. The ideal of the correct tone rendition is difficult to achieve, particularly in the case of contrasty subjects. The contrast of a subject is determined by the difference in brightness between the lightest and the darkest points and is expressed as a ratio. For general subjects the contrast lies between 1:10 and 1:1000. The portrait of a blonde girl with light complexion, uniformly lit, would be about 1:10 (3 f/stops). If the hair is dark and the complexion light, the contrast could be as much as 1:100 ($6^{1}/_{2}$ f/stops). A hazy landscape in diffused sunlight is about 1:30 (5 f/stops); but if the sky is blue and the landscape is bathed in direct sunlight, this could rise to 1:100, perhaps even to 1:250 (8 f/stops). For shots against the sun, and interior views against a window, it could be as high as 1:1000. The problems arise because the film cannot accommodate so much contrast.

I shall only give you the limiting values. Subjects with contrasts of about 1:50 will be reproduced in the colour negative and in the colour print without any loss in the light and dark areas. The only condition is that you expose for the average values within the subject. In fact a subject that has a contrast value of exactly 1:50 ($5^{1}/_{2}$ f/stops), will be reproduced exactly on colour print paper, that is with a contrast of 1:50. All subjects with contrasts higher than 1:50, but under 1:300, will be captured on colour negative film without losses in detail, but when they are printed they will lose detail in the light or the dark areas, or both, depending on whether they are printed

lighter or darker. Subjects with even greater contrast values than 1:300 cannot be accommodated by the film without suffering losses. In such cases you have to decide when taking a picture, whether the light areas (minus correction) or the dark areas (plus corrections) are more important.

When using slide film the extra step of printing need not be considered, but the limits of exposure and reproduction are drawn even tighter. As mentioned already, subjects with contrasts of 1:35 (about 5 f/stops) will be captured on slide film without losses, as long as the metering was taken correctly. Even subjects with higher contrasts, up to about 1:250, will still be acceptable, provided the slide is correctly projected. In this case all the fine details beyond the 1:35 limit will be there in the light and shade, but will only be seen properly if you project the slide at the correct brightness level onto a good reflecting screen, and with a good, properly focused projector. But if such slides are printed on paper, the result is usually disappointing. There will be a noticeable loss of detail which can start with subjects with contrast values as low as 1:15.

The rules for exposure of colour negative films and colour slide films can be summarised as follows. When taking photographs with colour negative film you have to bear two possible situations in mind:

◯ For subjects with contrast values of up to 1:300, which corresponds approximately to 8 stops between the brightest and the darkest point of the subject, you should have no problems as long as you expose for the average brightness. If you then find that the shade in the print has turned out too dark, or the light areas too pale, you should return it to the lab and ask them to reprint it.
◯ With subjects of high contrast you should decide at the time of taking the picture whether you wish to preserve details in the light or in the dark areas and to make the exposure correction accordingly. To make your shadows brighter, you need to correct on the plus side, to guard against too much brightness, you have to make minus corrections.

When photographing with slide film you need to follow the following advice:

○ Always expose slide film correctly. It might be necessary to make corrections even for subjects with average contrast values. If the subject is very contrasty, exposure correction is absolutely essential. Metering the important part of the subject will help in such cases. You will have to meter close up to the light or dark area, whichever contains the important statement. The best shooting mode for this is the manual mode, or if you wish, use the automatic exposure lock and aperture priority.

It's all in the measurement: Apart from subject luminance, light metering can also be a problem, if optimal exposure is required. After all, every light meter has to be calibrated to a nominal value. In photography, average grey is used as the nominal value. This means a subject with average brightness, or more precisely it means a subject with 18% reflectivity. A subject which is defined as average grey therefore reflects 18% of incident light. So if we photograph a piece of grey card having a reflectivity of 18% (like the Kodak grey card) across the whole frame, then the exposure measurement system in the camera will measure the reflected light, compare this level of brightness with its internal calibrated standard, and calculate the correct exposure value taking into account the set film speed.

It is unimportant in principle whether the exposure time is calculated for the preset aperture (aperture priority); whether the aperture is calculated for a preset shutter speed (shutter speed priority); whether an automatically set shutter speed and aperture combination is used (program mode); or whether a manually selected aperture and shutter speed combination is chosen.

If the camera works properly, then it is this exposure value that will reproduce the grey card as a colour print with normal enlargements or as colour slide viewed at the correct brightness. You can check this by comparing a colour print with

the original grey card. Of course, development of the film must be properly carried out and the correct exposure must be given when printing from the negative. To compare a slide with the grey card is a little more difficult. After all, the reproduction of the slide also depends on the brightness of the projection light. In any case, provided the exposure and development of the slide film was correct, the colour reproduction of the projected slide must give the impression that the brightness lies halfway between black and white.

Whether a uniformly average grey object is lit by a bright or by a dim light does not matter, the camera has to adjust the exposure so that an actual average grey is always reproduced as such. Unfortunately most subjects are not uniform in brightness. Just think about the example of the back-lit shot. If you take a group of people against a bright sky, then the bright light from the unimportant background will dominate the light measurement and result in a relatively bright average for the overall picture. The exposure level calculated by the camera will result in the group of people being represented as silhouettes against the light. To compensate for this incorrect measurement, due to the high contrast, you will have to increase the exposure level by up to two stops. This means that the necessary exposure correction will depend on how much sky is included in the frame and where the bright sky lies with respect to the centre-weighted measuring circle of the F-501. Only after this compensation has been applied will the important statements in the picture be correctly represented, i.e. correct in their tone rendition. The blue in the sky will probably no longer be apparent and any white clouds will have merged into the washed-out sky.

Alternatively you could use manual exposure settings, or the automatic exposure lock in aperture priority mode, by taking a reading close to the group of people and using this reading for the exposure, by storing it manually or

The autofocus even works perfectly in this situation with low subject brightness. Slide film 640 T required aperture f/4 and $^1/_{125}$ sec.

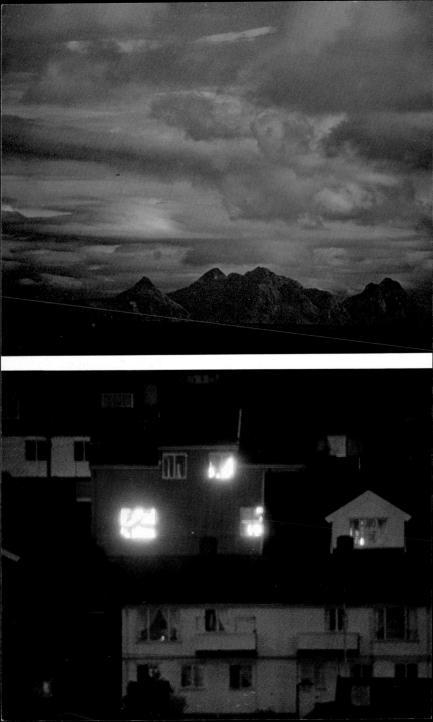

electronically. However, when taking a light reading in this way you should never choose a black coat or a white dress for the measurement, but always the average grey of the group of people. In practice the difficulty will often be finding the right area to measure the average grey. As mentioned previously, in such cases it would not be wrong to let one of the group hold the grey card, in order for you to get the right value.

Snowmen must be snowmen and chimney sweeps chimney sweeps: Apart from very contrasty subjects, with a wide brightness range and where the dark and bright areas are unbalanced, there are other subjects with problematic reflectivity. One is where white is on white and the other is where black is on black. If you photograph a snow-covered landscape you will usually be disappointed; the brilliantly white snow turns out to be a dirty grey. The camera's light metering system has interpreted it as an average grey subject, but extremely well-lit, and indicated a very small exposure to compensate. If the snow needs to stay white, it will therefore be necessary to compensate by up to two stops. At the other extreme the camera will interpret a dark coal cellar as badly-lit average grey and it will be necessary to underexpose by up to two stops to achieve a good black.

Exposure corrections are possible from -2 to +2 stops. An exposure correction of +2 for example, would correctly expose a white snowscape.

The sunset and the fishing village at night were taken with the 500mm mirror lens, camera supported on a tripod of course. Pointing the AF metering field onto the brightest area it was even possible to use the autofocus f/2.8 at 1 sec and 400 ISO film with automatic focusing.)

In conclusion: If you are dealing with subjects with unbalanced and strong contrasts, or with those of unusual reflectivity, such as white on white or black on black, you will have to apply corrections to the automatic exposure settings. Only then will you obtain correct tone rendition. The F-501 offers several methods for dealing with this situation. You can use aperture priority mode or the program modes and the appropriate corrections. A good method in shutter speed priority mode is to measure the subject close up and use the automatic exposure lock. If you have enough time you can work in manual mode. If you measure a suitable area around your subject, or use a grey card at a suitable position, then you will obtain the right value for your picture.

Flash In Program Mode

If you use the program modes of your F-501 you will be able to take one picture after another without first having to take a degree in photography. The occasions when the camera's electronics cannot properly cope, as described previously, are not that frequent. More often we encounter situations where there is not enough light; then we have to use flash. If you use one of the Nikon system flashguns, such as the SB-18, SB-15, the SB-16B or the new SB-20, then you will not have to exert yourself much either, provided you use them in the program mode. You simply set the program mode on the camera to P DUAL, P or PHI, set the shooting mode selector on the back of the flashgun to TTL, and the F-501 will automatically switch to synchronised flash mode. A slight pressure on the release button will indicate $^1/_{125}$ second in the viewfinder and the flash symbol will light up. This means that the camera has set the shutter speed to $^1/_{125}$ second and the lit LED means that the flashgun is charged and ready for use. Now you only need to focus on your subject, or let the AF do it for you, and release the shutter. The camera computer will select the appropriate aperture and the amount of flash will be correctly calculated. You will generally produce correctly illuminated flash shots and can use the camera in this mode as a snapshot instrument. If your flashgun is the SB-20, then you can do it even in total darkness.

TTL Synchronised Flash – Things To Keep In Mind

If the flash symbol in the viewfinder flashes several times immediately after the shot has been taken, or if it goes out for longer than one second (only with SB-18) with the shooting mode selector set to P DUAL, and the system flashgun to TTL, it means that the exposure time was insufficient, i.e. the

Flash Units and Accessories

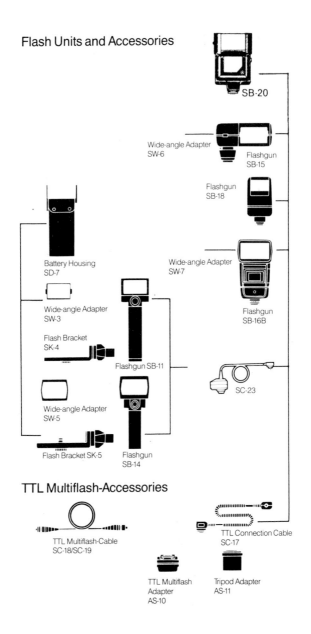

SB-20

Wide-angle Adapter
SW-6

Flashgun
SB-15

Flashgun
SB-18

Battery Housing
SD-7

Wide-angle Adapter
SW-7

Wide-angle Adapter
SW-3

Flashgun
SB-16B

Flash Bracket
SK-4

Flashgun SB-11

SC-23

Wide-angle Adapter
SW-5

Flash Bracket SK-5 Flashgun
SB-14

TTL Multiflash-Accessories

TTL Multiflash-Cable
SC-18/SC-19

TTL Connection Cable
SC-17

TTL Multiflash
Adapter
AS-10

Tripod Adapter
AS-11

subject was too far away. The TTL synchronised flash mode will always expose correctly up to 3.5m with a 100 ISO film at guide number 20, and up to 5m at guide number 32.

How the TTL flash program works: The secret of the TTL synchronised flash mode lies in automatic aperture setting to a value suitable for the film speed and the TTL flash metering, which will be described elsewhere. If a 100 ISO film is loaded the aperture will be set to f/5.6. For those of you who wish to know the technical details I have included a table for various film speeds and aperture values.

ISO	12	25	50	100	200	400	800	1600
Aperture	f/2.0	f/2.8	f/4	f/5.6	f/8	f/11	f/16	f/22

These aperture values are chosen to allow a distance of up to 5m with system flash units of guide number 20. For photographs in dark rooms the available light will be at least two to three stops less than the flash. Therefore you may be reasonably sure that there will be no annoying superimposed images due to the ambient light. Even if you are using the flash as fill-in, these aperture values will generally be quite suitable. For the lower film speeds though you have to take into account that the depth of field diminishes rapidly with larger apertures. It is therefore recommended to use film speeds of at least 100 ISO, 200 or even 400 ISO. Those of you who are specialists will want to know a little more about fill-in flash and how you can use this in the aperture priority mode together with normal TTL flash setting.

Picture creation with TTL flash mode: If you are using one of the system units SB-11, SB-14, SB-15B, SB-18 or SB-20, it is easy to use the flash in A-mode. The only difference from the programmed flash mode is that you select the aperture values, within reason, yourself. This means that you are still able to determine depth of field, even when using the flash. If depth of field is important you can work with smaller

apertures, but if you wish to have shallow depth of field you work with large apertures, depending on whether you want to show your subject in front of a sharp background or prefer to emphasise the subject in front of a blurred background.

Unfortunately you are somewhat limited in the range of aperture values by both the distance of the main subject and the film speed. The following table will demonstrate this for the Nikon system flash SB-20 with reflector set to normal:

	Film speed							Distance range*		
	1000	800	400	200	100	50	25	W	N	T
Aperture	2.8 + ¹/₁	2.8	2	—	—	—	—	2.8 ~ 20	3.8 ~ 20	4.5 ~ 20
	4 + ¹/₁	4	2.8	2	—	—	—	2.0 ~ 15	2.7 ~ 20	3.2 ~ 20
	5.6 + ¹/₁	5.6	4	2.8	2	—	—	1.4 ~ 11	1.9 ~ 15	2.3 ~ 18
	8 + ¹/₁	8	5.6	4	2.8	2	—	1.0 ~ 7.8	1.3 ~ 10	1.6 ~ 12
	11 + ¹/₁	11	8	5.6	4	2.8	2	0.7 ~ 5.5	1.0 ~ 7.5	1.2 ~ 9.0
	16 + ¹/₁	16	11	8	5.6	4	2.8	0.6 ~ 3.9	0.7 ~ 5.3	0.8 ~ 6.3
	22 + ¹/₁	22	16	11	8	5.6	4	0.6 ~ 2.7	0.6 ~ 3.7	0.6 ~ 4.5
	—	—	22	16	11	8	5.6	0.6 ~ 1.9	0.6 ~ 2.6	0.6 ~ 3.2
	—	—	—	22	16	11	8	0.6 ~ 1.4	0.6 ~ 1.9	0.6 ~ 2.2
	—	—	—	—	22	16	11	0.6 ~ 1.0	0.6 ~ 1.3	0.6 ~ 1.5

*Zoom reflector setting

These values show that the range of possible aperture values is greatest for subjects at 2.5 to 3.5m distance. The intermediate values are, of course, also possible.

What you have to consider with TTL flash: With shooting

TTL synchronised flash. Selector positions on the camera (left) and on the flashgun (right).

mode selector to A, flashgun selector switch to TTL, you select the required aperture value. If the flashgun is not the SB-20 you will have to focus manually if it is too dark for the autofocus. If the flash symbol flashes several times immediately after taking the photograph, then the flash was not strong enough, i.e. the distance to the subject was too great or the film speed too low. Your picture could be underexposed. You should repeat the shot with a wider aperture.

Fill-in flash for against-the-light shots: Everyone who has ever tried it will know how difficult against-the-light shots can be. If you are photographing a subject in front of a brightly lit background with the F-501 it will turn out more or less as a silhouette, depending on what proportion of the subject covered the measuring circle. You can correct the meter reading by including correction factors of up to +2 stops. Another possibility is to use aperture priority mode and the automatic exposure lock with directed measurements. All this

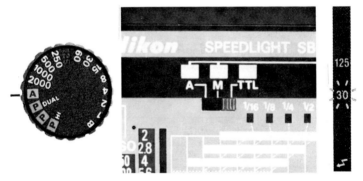

To use TTL controlled flash for filling-in the foreground in backlit shots you select automatic TTL mode. Set shooting mode selector to "A" (aperture priority), select "TTL" on the flashgun, select a suitable aperture to produce the desired background brightness. In our example the viewfinder display showed $1/125$ sec. flashing $1/30$ sec. This means that the background will be two aperture stops darker than the foreground. For a brighter background the aperture will have to be opened up.

has already been described in detail elsewhere. But even if you should apply these techniques correctly, the resulting pictures will not always be what you had wanted. The background would by necessity be too light and washed-out, and the colours of your main subject would not always be very good because of flare.

Under these circumstances the real expert would use the aperture priority mode and the TTL controlled system flash as so-called fill-in-flash. If the main subject is more or less within the centre measuring circle in the viewfinder, then in most cases the TTL synchronised flash will produce satisfactorily illuminated subjects. Not only will the colours of your main subject be rich and glowing, but you will also be able to show the background exactly as it is, or darker, or lighter. The presentation of the background will depend on the brightness of the flash relevant to the ambient illumination, i.e. the background lighting. The main subject in the foreground, independent from the selected aperture, will always be sufficiently lit, thanks to the automatic TTL setting. The brightness of the background, however, will depend on the aperture value. The shutter speed will always be $^1/_{125}$ second, the flash synchronisation time, and the background will be relatively bright with large apertures and relatively dark with small apertures.

If you take pictures against the light with an 100 ISO film with TTL flash synchronisation and a preset aperture of f/5.6, and if the display in the viewfinder before taking the shot shows the flash synchro time of $^1/_{125}$ second with $^1/_{250}$ second also flashing, then the background will be relatively light. This is because in effect you have exposed with f/5.6 and $^1/_{125}$ second, twice the value that the aperture priority had calculated as sufficient. If you select aperture f/8 under the same conditions then the foreground and background will be approximately of the same brightness. With aperture f/11 the background would be somewhat darker. Of course, all this also depends on the relative brightness of the subject against the bright background and also on the position of the metering circle in the viewfinder.

Fill-in flash with TTL measuring - what you have to consider: In principle there is no difference whether you use the TTL flash in aperture priority mode for interiors, or in dim light outside, or if you use it as fill-in flash for against-the-light shots, in principle there is no difference. The only difference is that you will be determining not only the depth of field, but also the brightness of the background when using the flash as a fill-in when you are preselecting the aperture setting. As a general rule you could remember: small apertures (in addition to the flash synchronisation speed of $1/125$ second, a longer time is also flashing in the viewfinder) result in a relatively darker background; large apertures (a shorter time blinks in addition to the flash synchronisation time) result in brighter backgrounds.

TTL controlled multiflash: You can use more than one flash with any camera. To do this you have to use so-called "slave units" in addition to the main flash which is triggered by the camera. After a little experimentation you can use this to great effect; for instance, to brighten up dark areas in the background, or to simulate charming little against-the-light scenes, and much more. All you need is experience. If this were possible with TTL flash synchronisation, then wrong exposures would be impossible from the start! Now, if you are using a F-501 with system flash units from Nikon, then you will be equipped with an almost fool-proof TTL controlled multiflash unit.

Another bit of good news is that relatively few accessories are needed to make all this possible. All you need, apart from the flashguns, are one or more TTL multiflash adapters (AS-10), a flash shoe adapter cable (TTL cable SC-17) and a few connector cables (TTL multiflash cable SC-18).

The flash units should have similar illumination time characteristics to ensure that the simultaneous TTL control of several flashguns works properly. However, in practice this is often not critical if you remember the following general rule:- When using multiflash always use the strongest flashgun on the

TTL controlled Multiflash. You can use several flashguns simultaneously with the TTL controlled automatic flash. Apart from the flashguns you will need at least one viewfinder shoe adapter cable (TTL Cable SC-17) and the appropriate number of multiflash adapters (TTL Multiflash Adapter AS-10) and connector cables (TTL Multiflash Cable SC-18)

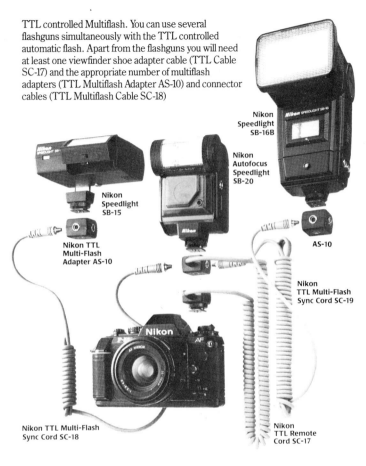

Nikon Speedlight SB-16B

Nikon Autofocus Speedlight SB-20

Nikon Speedlight SB-15

Nikon TTL Multi-Flash Adapter AS-10

AS-10

Nikon TTL Multi-Flash Sync Cord SC-19

Nikon TTL Multi-Flash Sync Cord SC-18

Nikon TTL Remote Cord SC-17

main subject, the weaker ones can be used for filling-in the background, for special effects or similar.

This is how the TTL auto-flash works: The special advantage of the TTL auto-flash against the conventional auto-flash units is that they offer the possibility of free aperture choice, including the intermediate values, and fairly precise light measurement of the subject across the whole field of view. The measuring cell in an auto-flash unit usually has a

116

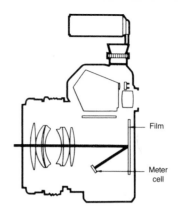

This is how TTL controlled flash works. When using system flash units in the TTL mode the camera measures the light reflected from the film surface during the shutter opening time. If it is enough, then the camera switches the flash off. The distance and the brightness of the subject and the aperture value are considered in this measurement.

Film

Meter cell

fixed angle of view of about 60°. That means that the measuring angle corresponds to the lens viewing angles between 40-50mm. If you are using a wide-angle lens with greater angle of view, or a telephoto lens with considerably smaller angle of view, then the values metered by the flashgun will be more or less wrong. Apart from this, most auto-flash units are limited to a certain number of aperture stops, usually two or three.

Of course, the F-501 will work perfectly with the system flashguns by Nikon, and other compatible makes of dedicated flashguns may also be used in the 'A' shooting mode with fully automatic TTL flash control. Connecting one of the Nikon system flashguns will first set the flash synchro speed to 1/125 sec. If you then release the shutter the flash will fire after the mirror has folded away. The aperture will have been stopped down to the working value and the shutter blinds will be completely open. The meter cell at the bottom of the camera will then measure the light reflected from the film surface during the following $1/125$ second when the shutter is open, and control the flash illumination time according to this measured value. Therefore it does not matter whether the time additionally indicated in the viewfinder in the aperture priority mode was $1/30$ second, $1/250$ second or even 1 second. If a system flash is attached, the shutter speed is always $1/125$ second. This is also the reason why a non-compatible flash or a manual flash that cannot transmit the signal "change to flash

synchro time 1/125 sec", will expose at any shutter speed indicated in the viewfinder in the program modes P DUAL, P, PHI and A. This will inevitably lead to incorrect exposure levels, streakiness or similar faults. If you wish to use one of these flashguns then you need to set the time of $^1/_{125}$ second by hand.

Now back to TTL flash control. This is the control of the flash duration by the camera's electronics, based on the metering of the brightness reflected from the film surface. The selected aperture has no influence on this measurement. The different aperture values are automatically taken into account with the differently selected flash illumination values. But as with any other automatic setting procedure, this too has its limitations. After all, it does need some time, which is admittedly very short, to measure, calculate and send the stop signal to the thyristor of the flash unit, and there is also the response time of the thyristor. If the required illumination time is noticeably shorter than the response time of the equipment, then this will definitely result in overexposures. Overexposure is bound to occur with TTL controlled flash if the distance to the subject is very short, compared with the guide number of the flash unit, or if the selected aperture opening is too big or the film speed is too great.

The solution to this is to stop down, or to use a slower film. You could also use a neutral density filter in front of the flash. Another source of incorrect exposure may be that the subject is too far away from the camera and that the amount of light that the flash is able to project is insufficient. The maximum range of the flash, which is smaller for a small aperture (large f/number) and larger for the large aperture (small f/number) corresponds to the flash range of the flashgun in normal manual use. It is a fact that even the best TTL flash control cannot do more than trigger the full blast of the flash. If this is insufficient then you either have to go closer or you have to use a faster film.

The limits of TTL auto-flash: Even if we consider all the

good virtues of TTL auto-flash, it is still subject to natural limits. Difficulties can arise with film surfaces of different reflectivity. After all, how would you know whether an Ektachrome 100 has the same reflectivity as a Fujichrome 100, or an Agfachrome 1000, or any other of the wide range of films available. Perfectionists will have to calibrate the setting of the film speed for use with the TTL flash. But the tolerances could not be too great, at most $+/-^1/_3$ stop at the outside.

TTL auto-flash can bring some other pitfalls. Although the metering will automatically adjust to the angle of view of the lens, because of the heavily centre-weighted metering of the F-501, this could be incorrect to a greater or lesser extent. The centre-weighted metering with a 50mm lens will cover about 30% of the important section of the subject in the central area of the measuring disc. This percentage value is smaller for lenses with very short focal lengths and greater for long telephoto lenses. A further problem is that the important part of a picture is not always at the centre of the frame. I recommend that you take a series of test pictures, especially if you are working with slide film, to familiarise yourself with your camera's characteristics.

TTL auto-flash metering is based on a calibration of a subject of average reflectivity. This calibration to the so-called average grey can have serious effects on the measurement and regulation of the flash. For example, if you are photographing dark, poorly-reflecting objects they would be excessively brightened and would therefore look quite unnatural. On the other hand, very bright, strongly reflecting objects, would turn out too dark. The bride in white in front of a white wall will look too dark and the black widow inside a dim church will be too bright. In cases such as these you will have to make the necessary exposure corrections by using the exposure correction facility.

For subjects with great contrast range the auto-flash is also not ideal. You will have to apply your experience and decide whether you wish to expose for the dark or for the light areas and then make the necessary exposure correction.

TTL auto-flash helps you in many situations to act faster and take better pictures, but if you apply your head at the same time, you should always come out on top.

No need for an auto flashgun: If you have a camera that offers automatic TTL flash setting, and then go out and buy an expensive auto flashgun, I can only say "more fool you". Nevertheless, I can think of some circumstances where this might be excusable. You may still have a well-tried flashgun from your old equipment, or perhaps you use the flash only once at Christmas, when the whole family is sitting around the turkey. Under these circumstances it might be sensible to buy a cheap auto flash. In any case I have here a few tips on the use of auto flashguns with the F-501.

Install the flashgun on the camera, manually select shutter speed $1/125$ second, select the appropriate aperture for the film speed which may be read off from the table on the flashgun, check whether the subject is within reach of the flash, and press the trigger. The light cell in the auto flashgun will then automatically measure the reflected light and control the flash illumination time accordingly. Generally speaking you will get reasonably well-lit pictures using this method.

Manual Flash

What has been said about auto-flash can be applied, to a certain extent, to manual flash when used with the F-501. Using a manual flashgun with the F-301 is something of an anachronism, but the argument advanced by some professional photographers is that you can expose more accurately with manual flash than with any type of automatic. This is true only if you also employ a very expensive flash exposure meter and to use such equipment properly requires a certain amount of know-how.

But why shouldn't you carry a simple manual flashgun with you? Here are a few useful hints. When using a manual flashgun with the F-501, always set the exposure time to $1/125$ second.

Select the appropriate film speed on the scale of your flash unit and read off the appropriate aperture setting for your subject. Now you only need to release the shutter. All this can be done quickly and easily. However, only a few subjects are entirely flat and equidistant from the camera. Most subjects have a certain spatial depth. Just think about the bride and groom's table at a wedding feast. If you select an aperture for the distance to the centre of the table, you may find that the bride in the foreground looks quite pale and washed out, mother-in-law at the centre looks nice in her new hat, but only the nose of the parson at the end of the table glows out of the darkness. Even if you bounce the flash off the white ceiling the results may be varied. So what aperture should you choose?

Compared with manual flash the use of an auto flashgun or even better the TTL auto-flash is more convenient and more precise by far. Bear in mind that the aperture selected according to guide number and distance is not exactly foolproof. Reflections from surrounding objects can influence the readings. If you are taking photographs in the open air, or in large rooms, it will probably be necessary to make appropriate corrections, i.e. to open up the aperture by a certain factor.

Of guide numbers, apertures and distances: Thanks to auto flash, or even better, TTL auto-flash, this field of photography is now open to anyone, without the need for complicated calculations and settings. Even so, the dedicated amateur photographer will still be interested to learn all the basic rules. This comes in useful from the start when you are trying to decide what flash outfit to buy. Should you go for the one with guide number 32, or is guide number 30 just as good? Would you have known that a flashgun with guide number 32 would reach only 25 cm further with aperture f/8?

The guide number is that value which takes into account all the parameters which have any bearing on the exposure level. The law that brightness decreases as the square of the distance applies also to flash photography. If we have an object at 2m distance from the flash, another at 4m, and a third at 6m,

then the subject at 4m distance will be only one quarter as bright as that at 2m, and the one at 6m distance will be only one-ninth as bright as the first. This is what is expressed by the guide number. The guide number refers not only to film speed, but also to the brightness and hence the distance covered by the flash. If the film speed and the distance to the subject are known, the aperture may be calculated by knowing the guide number of the flash:

$$Aperture = guide\ number/distance$$

The distance at which a subject may be correctly illuminated at a given aperture and flash output may be calculated as follows:

$$Distance = guide\ number/Aperture$$

The present convention is to express the guide number for a film speed of 100 ISO. If we use a flashgun with guide number 32, with a 100 ISO film in the camera, then a subject at 2m distance would be correctly illuminated at aperture f/16 (= 32/2). If the distance is increased to 4m, the aperture would have to be opened up to f/8 (= 32/4). Or the other way round: with aperture f/4, a subject at 8m distance would be correctly illuminated, but with f/11 the subject would have to be at 2.9m from the camera. But you do not have to make these calculations yourself. The flash unit should have a calculator table from which you can read the distance and aperture combinations which are correct for your flashunit.

In the case of auto flash units and TTL auto-flash the guide number represents the maximum output of the flash. If the subject or the distance requires less illumination, the automatic metering will regulate this by reducing the illumination time. Most of us will be glad that the auto-flash has released us from this cumbersome calculation.

Just after the sunset. The tungsten light in the room emphasises the colour of the window frame in contrast to the deep blue light outside.

Flash tailored to the subject: There is hardly a subject that is not suitable for flash photography. Let's start with one of the most frequent topics – the photograph for the family album. Whether it is a birthday party or a happy family reunion, most of these pictures are taken inside and at distances of between 1.5 to 3m. Lenses between 35mm and 85mm will be the most useful focal lengths for these situations. To complement them, a flash with guide number 20 and films with speeds 100 ISO or 200 ISO should cover almost any situation. When pointing the flash directly at the subject you have to be careful that the difference in illumination for various elements in your picture is not too great.

As the illumination intensity decreases with the square of the distance, the foreground could be too bright, or if the foreground is correctly illuminated, the background could be too dark. Even if you use TTL autosetting, it will be difficult to find the right compromise, especially if you are working with slide film. Try to bounce the flash from the ceiling; this usually produces good results. To avoid unnatural looking portraits, place a diffuser in front of the flash and bounce the flash as well to soften the light. If your flash has no diffuser you could attach a piece of tissue paper loosely to the flash reflector.

A flash mounted directly on top of the camera is particularly unsuitable for portrait photography. It often results in the well-known "red-eye" effect. This is caused when the axis of the lens and that of the subject are in line and the light is reflected from the back of the eye. If there is an angle between the object and the flash axes, then the red light is reflected away and no longer registered in the picture. If you are using a "hammer head" flash you should not have any problems on this account. Another way to avoid the red-eye effect is by using the diffuser and by bouncing the flash.

TTL controlled fill-in flash. The aperture determines the brightness of the background. Without flash, at f/8 and $^1/_{125}$ sec. (top left), with flash at f/8 (top right), with flash at f/5.6 (bottom, left), flash at f/11 (bottom, right).

For interior architectural views you will need a strong flash to illuminate large areas. By definition the space will be limited and you will almost certainly have to use a wide-angle lens. This in turn will necessitate the use of a wide-angle diffuser in front of the flash.

Telephoto lenses dominate in the field of sports photography. As well as flash you should also use faster films, together with a tele adapter to concentrate the light of the flash. By the way, the use of flash is usually not allowed at official races. Portraits and still-life in studios usually require strong flash output because rather slow, fine-grained films are normally used. The illumination has to be arranged to be uniform and to avoid deep shadows and hard contrasts. A reflector screen will change a hard flash into a softer light source. An additional white or silver reflector screen (cardboard covered with aluminium foil, polystyrene board or similar) will reflect light into the dark areas. A background of the appropriate lightness or colour will add the right mood to your composition.

The most controlled results are achieved when you use more than one flash (multi-flash). In that case three flashguns should cover any conceivable situation. The strongest flash is usually positioned more or less in front as the main illumination, for specific subject themes it might be positioned as top-lighting. If you are not using a flash reflector, you could substitute a large sheet of transparent paper which you could hang about one metre distant from the flash between the main subject and the flash. A special diffuser foil is equally suitable of course. A second, weaker flash can be used to brighten up the background to the required degree or to fill-in from below. The third flash could be used to pick out or emphasise certain areas, for example as a highlight. Your flash equipment will not be provided with modelling lights as is the case with studio equipment, but this need not worry you. Two cheap clip-on lights, using 60 watt reflector bulbs, should serve as perfect modelling lights.

Similar arguments apply to table-top pictures. Only here we

have smaller subjects and uniform illumination can be achieved by some different tricks. The secret here is a light tent made of translucent paper or plastic foil, illuminated by two flashes, one on the right, the other on the left. Experts would perhaps use ring flash, but even that does not automatically produce good pictures.

Reproductions are best made by using two matched flash units, positioned on the right and left at 45°. The distance to the picture to be copied for sizes up to DIN A2 should be about 80cm. Diffuser foils are also recommended for this application.

Actual macro photography is best done with multiple flash. The SB-15 with a multiflash cable and a multiflash adapter is suitable for this application. If the brightness is too great you could use a neutral grey filter foil. Ring flash could be a good choice for macro photography, but here too they do not guarantee success.

Duplicating slides with flash has proved very successful. However, one limitation is that the TTL auto control becomes ineffective because of the low nominal speed of only about 6 ISO of Kodak slide duplicating film. You will have to experiment with various distances of the flash, or by using various ND filters to test for the best conditions. For slide duplicating it is necessary to use colour filters and it would be best if you got a set of colour compensating filters (Kodak or Hama).

Flashguns Made to Measure for the F-501

The Nikon flashguns SB-15, SB-16B, SB-18 and above all the SB-20 are tailored for the F-501. You can use the TTL auto control in the aperture priority mode and also the TTL autoflash program. You can also use the TTL-compatible "hammer head" flash units SB-11 and SB-14, for which you need connector cable (SC-23). For recording movement sequences Nikon has provided the stroboscope flash SB-6.

The Nikon
"System Flash"

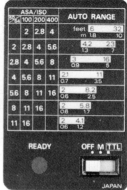

	ASA/ISO			AUTO RANGE	
50/64	100	200	400		
	2	2.8	4	feet 6	32
				m 1.8	10
2	2.8	4	5.6	4.2	23
				1.3	7
2.8	4	5.6	8	3	16
				0.9	5
4	5.6	8	11	2.1	11
				0.7	3.5
5.6	8	11	16	2	8.2
				0.6	2.5
8	11	16		2	5.8
				0.6	1.7
11	16			2	4.1
				0.6	1.2

READY OFF M TTL

JAPAN

SB-18

SB-16 B

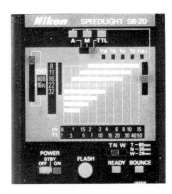

SB-15

SB-20

System flashguns SB-18, SB-16B, SB-15 and above all SB-20 are "made-to-measure" for the F-501. The SB-18 (top left) is a very handy and reasonably priced unit. The SB-16B is much more powerful and offers a range of facilities (left-hand page, bottom) The SB-15 (this page,top) is handy and powerful. The ideal flash for the F-501 is the SB-20 (this page, bottom). The reflector may be pivoted for indirect flash, has a zoom reflector for focal lengths from 28mm to 85mm, manual flash in five output levels, very fast flashing rate, large flash value, and, last but not least, AF infrared focusing flash.

For macro photography the two ring flashes SR-2 and SM-2 are available. The SR-2 can be screwed directly onto the 52mm filter thread of the Nikkor lenses, while the SM-2 can be fitted onto the bayonet of the Nikkor lens when it is reversed on the camera for macro work. The three last-mentioned flashguns can only be used manually, the TTL autosetting is inoperative. But the less experienced amateur photographer would probably not wish to use them anyway.

Nikon Flashguns compatible with the F-501					
Type of Flash	Guide Number	Focal Length with/without wide-angle diffuser	Batteries Number/Size	Flashing Rate	Number of Flashes
SB-11	36	35/28 mm	8 AA	8 s	150
SB-14	32	28/24 mm	6 AAA	8 s	270
SB-18	20	35 mm	4 AA	6 s	250
SB-15	25	35/28 mm	4 AA	8 s	160
SB-16B	32	85—28 mm Zoom reflector	4 AA	11 s	100
SB-20	30	85—28 mm Zoom reflector	4 AA	6 s	160

Flashguns By Other Makers

If you only use a flash infrequently and wish to carry one with you just in case, then a cheap manual unit would do just as well. If you consider range and convenience important, why not opt for one of the auto flash units. Those are available cheaply even with guide number 30. But if you do not want to do without TTL autosetting, then the SB-18 would be your best choice, and the price is very acceptable. If you wish to extend your flash equipment to multiflash then this unit could be easily combined with the SB-15 or the SB-20.

The Nikon flashunits SB-11 and SB-14 have not been designed for maximum output, but rather for professional needs. Very handy and with high guide number, they are ideal instruments for the reporter.

The decision becomes more difficult if you are dreaming of flash photography with all that's on offer round about guide number 30. The SB-15 and the SB-16B by Nikon should be quite a good choice. Particularly handy and universally applicable is the SB-15, but even at its relatively low guide number of 25 it cannot be called cheap. The SB-20 is definitely

the ideal flashgun for the F-501 and is able to cope with almost any situation.

If you look elsewhere, then one cannot really hold it against you. There is a good supply of units which are compatible with the Nikon. The use of system adapters will allow you to use these dedicated flash units even with the TTL autosetting on the F-501. As far as I was able to ascertain at the time of writing this book, the flash units of the series SCA-300 (by Metz, Braun, Cullmann, Osram and Regula) with adapter SCA-343 are fully compatible with the F-501. If you are playing with the idea of buying a dedicated flash by Sunpak, Vivitar or Unomat, then you should always ask before buying. Because of the rapid change in the camera and flash unit markets, the offer of adapters is always changing. An enquiry to the manufacturer by letter or telephone is always worthwhile.

The choice is somewhat more limited for the amateur photographer who insists on guide number 40 or over. The professional flash units SB-11 and SB-14 by Nikon, with guide numbers 32 and 36 respectively, are designed for the press photographer. Ambitious amateur photographers are known to be very demanding: it seems they dream of illuminating Canterbury Cathedral or some other vast edifice. If you are going for guide number 45, the 45 CT-4 by Metz (with adapter SCA-343) would be a good choice, but consider also the high-output units by Cullmann, Sunpak and Unomat.

If you want to go as high as guide number 60, the choice is restricted to one – the well-tried Metz 60 CT-2. I was told that it worked perfectly well with the F-501 and adapter system SCA-543.

AF-Lenses Only in the Future?

Even though the autofocusing mechanism of the Nikon F-501 works perfectly, one should not forget that this camera will also function with conventional lenses. With the wide-angle lenses up to 35mm in particular there is usually no particular advantage in focusing convenience. Super wide-angle and wide-angle lenses are generally used for overall views and landscapes, and focusing in the critical close range is generally not required. If you have one of these lenses from your earlier

AF lens	1	2	3	Filter Thread (mm)	Weight g	Diam. x length (mm)
AF 1,8/50 mm	●	●	●	52	210	65 × 39
AF 3,3-4,5/35-70 mm	●		●	52	275	70,5 × 61
AF 4/70-210 mm	●		●	62	760	76,5 × 148
AF 2,8/24 mm	●	●	●	52	255	65 × 46
AF 2,8/28 mm	●	●	●	52	195	65 × 39
AF 1,4/50 mm	●	●	●	52	255	65 × 42
AF Micro 2,8/55 mm	●	●	●	62	400	69,5 × 73,5
AF 2,8/180 mm IF-ED	●	●	●	72	720	78,5 × 144
AF 2,8/300 mm IF-ED	●	●	●	39	2600	132 × 255
AF 4/600 mm IF-ED	●		●	39	6200	173 × 466
AF 3,5-4,5/28-85 mm	●		●	62	540	71 × 90
AF 3,5-4,5/35-105 mm	●		●	52	500	69 × 87
AF 3,5-4,5/35-135 mm	●		●	62	600	68 × 112

1 = automatic focusing
2 = automatic focusing with AF converter TC-16A
3 = AF focus-assist

8mm — 180°

15mm — 110°

24mm — 84°

50mm — 46°

85mm — 28°30′

180mm — 13°40′

400mm — 6°10′

1200mm — 2°

equipment you can continue using it quite conveniently, and the focus-assist facility will help in more critical situations.

I cannot advise against buying a conventional Nikon lens with manual focusing, either secondhand or on a special offer, because these may become increasingly available at tempting prices due to the introduction of the new AF lenses. For standard focal lengths, and in particular for long lenses up to 200mm, I would not actually recommend buying a manual lens, but you may possess one already. They may be adapted for automatic focusing with the AF converter TC-16AW, provided they are fast enough (at least f/2.8). You could also think about investing in the AF-Zoom 35-70mm as the ideal lens to keep as your constant companion.

The best buy amongst the AF lenses is the AF Nikkor 180mm f/2.8 IF, ED. It not only has the best reproduction characteristics, but also the least focusing time due to internal focusing. The favourably-priced AF zoom 70-210mm f/4 is a worth-while alternative.

The longer AF lenses between 300mm and 600mm are a good bet for sports and animal photography, but their price and heavy handling take them out of the scope of the ordinary amateur photographer. In this range one would generally go for the conventional, manually-focused lenses and use the AF focus-assist facility.

Fixed Focal Lengths are not Old Hat!

If you own a good camera you will also want to buy a few good lenses for it. But which, that is the question. One zoom for everything is just about the worst advice anyone could give you. To be sure there are several arguments in favour of the

Comparison of focal lengths: Pictures taken with different focal lengths from the same position do not show any change in perspective. Because of the different angle of view, wide-angle lenses show more, but represent the view on a smaller scale; telephoto lenses select a smaller frame, but represent it on a larger scale.

zoom: you need not change the lens during shooting, which is faster and less distracting; you need not carry several lenses around with you; one all-in lens is cheaper than the sum total of several individual focal lengths. But almost all these arguments can be countered. One zoom lens can be so cumbersome and heavy that you might as well leave it at home. If you are using a zoom, you would not try to get the best viewpoint, but stand in one position and just twiddle your controls. Pictures don't get any better in this fashion. A zoom lens, whose picture quality is anywhere near that of a fixed focal length lens, would cost the earth. The present state of technology is capable of producing a zoom lens, using special types of glass, special lenses, floating elements and fine precision mechanics, that has the same quality of reproduction as high-quality fixed focal length lenses. Even maximum aperture, weight and overall dimensions need not be much worse, comparing quality with quality, than the bulkier and heavier of the two fixed focus lenses at the shorter and longer extremes of such a zoom.

There is only one thing wrong with the argument - nobody would be able to afford such a super zoom. This is the reason why the zoom lenses generally available have much slower

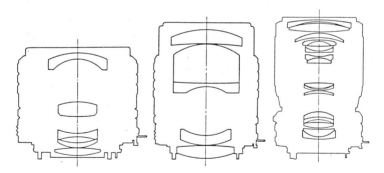

The cross-sections demonstrate advantages and disadvantages of zoom lenses. The fixed focus lenses 35mm f/2.8 (left) and 105mm f/2.5 (centre) manages with 5 elements, the 35-105mm zoom f/3.5-4.5 (right) has to use sixteen elements and the lens speed is considerably slower. It follows that the zoom lens is much heavier and, despite great optical complexity, much more liable to stray light and reflections. Its advantage: it covers both fixed focal lengths and all intermediate values in continuous setting.

speeds and why the optical problems which arise in their design are still compensated for by including extra elements. In this way a fixed focal length lens with nine elements becomes a zoom with fifteen and more. Even if this extra expenditure in elements compensates for the errors, the zoom will never produce better results than a fixed focus lens. One has to keep in mind that every extra element has two additional air/glass surfaces and however much multi-coating is used, the lens will lose contrast and become more susceptible to flare, the more elements are used in its construction. Don't ever ask for the maximum number of individual elements when you decide on a lens – it does not mean that you are getting value for your money.

In conclusion, we can say that every zoom – and the same is the case for fixed focal lengths – represents a compromise between range of focal lengths, lens performance, lens speed, weight, size and price. Except that the technical effort required is not so extensive with fixed focal length lenses compared with zooms and, at least in theory, their price should be more reasonable. Or the other way round, at the same price the fixed focal length lens will be technically more refined because the basic technical cost for a zoom lens is already that much greater. Another aspect to consider is that the basic pricing levels vary from manufacturer to manufacturer. An expensive fixed focal length lens from one manufacturer need not necessarily be better than a reasonably priced zoom from another. Don't make the mistake of dismissing either one or the other out of hand. For optimum quality at a certain focal length you should be best served by a fixed focal length lens, but a zoom should also present a good solution, as you may read further on in chapter "the ideal lens combination".

Focal Length –
The Character of a Lens

The essential difference between the individual focal lengths

for pictures from the same viewpoint, i.e. the same distance from the subject, is only the different scale of reproduction, which is a result of the different viewing angles. The normal focal length of a modern 35mm camera is about 50mm, which has an angle of view roughly corresponding to that of the human eye. More precisely, the human eye covers 43° and for this reason 40mm lenses are still very suitable as standard lenses. Lenses with focal lengths of 40mm and less, e.g. 35mm and 28mm, are considered to be wide-angle lenses. Focal lengths of 24mm, 21mm and 18mm are generally referred to as super wide-angle lenses.

Wide-angle pictures, taken from the same viewpoint, i.e. the same distance from the subject, differ from pictures taken with standard lenses in that they contain a lot more, i.e. they have a considerably larger angle of view. This in turn of course also means a smaller scale of reproduction. The spatial impression is also changed. However, if you enlarge a portion to the size corresponding to that which a normal standard lens would have shown, you will see that the perspective is the same at the same distance from the subject.

By reason of their construction wide-angle lenses at full aperture suffer from a much greater decline in illumination from the centre to the edge of the frame than do standard lenses. This effect increases with decreasing focal length. However, this has been corrected to a large extent for Nikon lenses. In addition, for the super wide-angle lenses there are also very noticeable distortions which are particularly apparent at the edge of the picture. These too are greater the smaller the focal length of the lens. Other effects in perspective, such as converging verticals, are more apparent with wide-angle lenses than with standard lenses. If we compare pictures at the same scale of reproduction then we find that the wide-angle view shows a different perspective to that of the standard lens. The items in the subject closer to the camera are emphasised in size with respect to a diminished background. We can regard pictures which make use of this characteristic as typical wide-angle views.

Lenses with focal lengths of over 55mm are generally called telephoto lenses. Photos taken with these lenses cover a smaller angle of view, but the reproduction scale is larger, the subject is drawn closer. In addition, the depth of the subject is compressed; it looks flatter. Fast telephoto lenses with good reproduction qualities are optically quite difficult to construct and therefore they are quite expensive.

The standard lens – a classic: It is obvious that pictures taken with a lens that has a similar angle of view to the human eye will look more authentic to us. Just look at pictures in a photographic gallery, or at collections of shots from photo journalists in the fifties and sixties. You will notice that there are a lot of pictures which give you the feeling that you are there yourself. This is due to a large extent to the expertise of the photographer, but it is also a consequence of the perspective given by the standard lens which was used then by the majority of photographers for most situations. It was not the fashion to simply zoom into the distance. No, the motto was: get closer to the subject! This is still true today!

We could say that the standard lens will produce realistic pictures of its own volition. Provided of course that you are not trying to show a view from an unnaturally close or too distant viewpoint. There is another important point. No other focal length has as much lens speed and reproduction quality as the 50mm lens. The greater speed is not only useful for available light photography, it offers in addition the possibility of sharply reducing the depth of field. As we mentioned previously: the larger the aperture, the smaller the depth of field and the better you can show the subject against a blurred background. It is questionable, however, if you should immediately buy the much more expensive 50mm f/1.2 instead of the 50mm f/1.4 – the gain in lens speed will be only $^1/_3$ of a stop.

Wide-angle perspective emphasises depth The normal wide-angle range starts with 35mm and includes the 28mm lenses. From 24mm, including 21mm and sometimes even the

28mm, these are called the super wide-angle lenses. As the heading indicates, these lenses are particularly suited to general-view pictures. No other lens will show a landscape better than a good wide-angle view. Whether you are showing rugged mountains or an endless flat desert, both types of view will be best served by the wide-angle lens. The wide angle of view gives the observer the distinct impression that he is there himself. Also for interior photography , whether you wish to show a living room or a large hall, the wide-angle lens is ideal. Often you cannot get far enough away from a subject with a standard lens. It is not only that this physical restriction makes the lens useful, but a view of a room with a wide-angle lens looks more natural. After all, we normally first look around when we enter a room, and the view from a standard lens is almost a "technical error" as it gives the impression of a sectional view. Of course, this is fine if it was the intention.

From a given distance the wide-angle lens will gather more onto your film than the standard lens, but as mentioned previously you only need to enlarge a certain section and the difference will be lost. The perspective therefore is only seemingly different to that of the standard lens for a given distance. It will change only when you take the wide-angle lens close up to the subject. If you go close enough to your subject to produce the same reproduction scale as that of the standard lens, then you will get quite different pictures. Not only will you see more in the picture than on the one with the standard lens, the perspective will appear distorted. In a portrait the nose, and especially the tip of the nose, will appear unnaturally large, while the ears which are further away from the camera will look unnaturally small. This example presents quite an impossible impression, but you can use the wide-angle lens to great advantage in showing certain impressions. After all, you usually intend to show and emphasise one particular aspect against the rest, the background. Particular in landscape

The 20mm wide-angle perspective puts the steps into close proximity, you feel you could just walk down! *Photo Wold Huber*

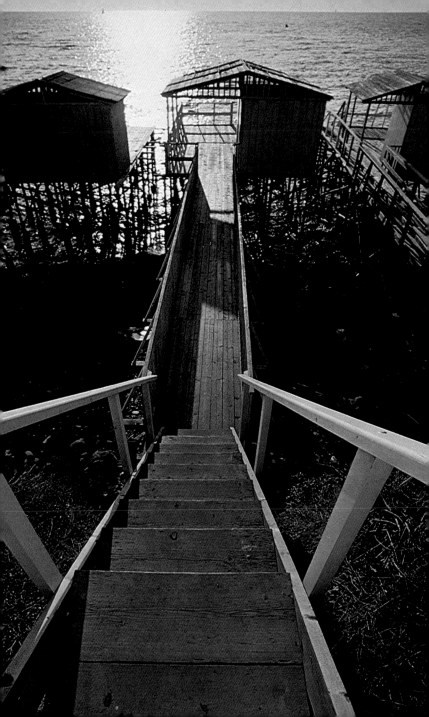

The AF Nikkor 50mm f/1.8 possesses all the advantages of the standard lens: high lens speed, good reproduction quality, compactness and reasonable price. Moreover, its angle of view closely resembles that of the human eye.

photography where you want to draw attention to a building, a tree, animals or people in a relatively emphasised foreground against a spacious, less emphasised background, a wide-angle lens close to, is the only way to do it.

No exposure problems with wide-angle lenses: When taking pictures with a wide-angle lens you have to consider that the light reading could be quite misleading as the wide viewing angle is not covered by the standard focal length. You could check this by taking the same subject in the open, on a tripod, and taking two shots; one with the wide-angle, the other with the standard lens. With the standard lens the bright blue sky will only cover a small section on the edge, which only makes a small contribution to the light reading, but with the super wide-angle the sky suddenly covers half your picture. The centre-weighted meter reading does not help in this case and your picture could well be underexposed. Don't worry, this does not present a problem with the F-501. You can switch to aperture priority mode and meter the subject by depressing the auto lock. You can then expose your frame with as much sky as you wish. Alternatively you can switch directly to manual light metering and store the value obtained without sky, then it does not matter whether your picture contains 80% or only 20% sky. The choice of frame is entirely up to you.

This coastal scene is beautifully rendered by the heavily emphasised foreground and spacious background. *Photo Wolf Huber*

Shift lenses correct converging lines: Very short focal lengths, can result in unpleasant distortions, particularly towards the edge of the picture. This is often very noticeable in interior views where vertical and horizontal lines are clearly defined. If the important detail is in the centre of the picture, then this does not matter too much. The same effect can be seen even with standard lenses when a tall building is taken from close range. By necessity you will be standing at ground level pointing the camera upwards, and if you are using a wide-angle lens this effect is considerably increased. You could turn necessity into a virtue and use the effect to produce an imaginative interpretation of reality. The viewer will be given a more powerful impression of the relative size of a building, and therefore you can make a statement from your own subjective impression.

1:3,5/15mm

1:5,6/13mm

1:3,5/20mm

1:3,5/18mm

If you want to include a lot in a frame you have to fit the wide-angle lens. The actual picture composition, however, starts with the correct use of perspective: over-emphasised foreground against wide spacious background.

144

1:2/28mm

1:3,5/28mm

1:2,8/28mm

1:2/24mm

E 1:2,5/35mm

1:2,8/24mm

1:1,4/35mm

E 1:2,8/28mm

1:2,8/20mm

1:2/35mm

1:2,8/35mm

145

PC 1:3,5/28mm

PC 1:2,8/35mm

Shift lenses where the lens axis, or in other words the lens head, may be shifted parallel to the film plane to compensate for converging verticals. Nikon offers two PC-Nikkor lenses of this construction.

But if you wish to avoid converging lines you will have to use a standard or a telephoto lens and take the subject from as great a distance and as high a level as circumstances will allow. The ideal position would be if you could float half-way up, keeping the optical axis horizontal, but this is not very realistic and you are always restricted in where you can stand. The only other way to avoid converging lines is by using a shift lens. These are wide-angle lenses which may be shifted parallel to the film. By using them it is possible to counteract converging lines right from the start. Nikon offers two shift lenses, the 28mm f/3.5 and the 35mm f/2.8.

With the eye of a flounder: If you compare an 18mm lens with a 28mm lens you will notice that the distortions at the edge are much more severe with the 18mm than with the 28mm lens. Furthermore, the subject will appear noticeably tilted with the 18mm and the other effects of wide-angle perspective, converging lines and an emphasis on the foreground, will be very much in evidence. Otherwise both lenses will have normal central perspective, i.e. the straight

146

lines in the direction of infinity seem to converge towards a common point, as is usual in the normal perspective.

However fisheye lenses give spherical perspective. Only the lines which cross the centre point of the picture will be represented as straight lines without any distortion. Any other lines emerging from the edge will not run parallel with the

1:2,8/6mm

1:2,8/8mm

1:2,8/16mm

These fisheye lenses shatter the world of the standard angle of view. These pictures cannot be called beautiful, but for scientific purposes such lenses are now indispensable. The diagrams show the difference in construction of a standard lens (right) compared with the fisheye lens (left).

centre point lines, as is the case with other lenses, but will curve around it. This might not be quite as bad as it sounds, but you will rarely obtain beautiful pictures with fisheye lenses. Lenses with an 180° or even 220° angle of view are used mainly in technical applications.

To photograph a large computer plant, say, at one glance is only possible with a fisheye lens. Apart from the great weight and a price to match, these extreme lenses are not fun to use. First you always have to be careful that bits of your own anatomy, like your ears, do not frame the picture, and then there is always some other disturbing factor you cannot exclude. When I had the pleasure some years ago of using a 180° fisheye it gave me little satisfaction, there was always something like a telegraph pole in the way and the landscape photographs I had looked forward to never quite materialised. If the weather was dull, even the fisheye could not make it any brighter, and if the sun shone then there it was in the middle of the view, producing the most unwelcome reflections. My fisheye soon found its way to the second-hand market.

The portrait focal lengths: The focal lengths between 85mm and 105mm can justly be described as portrait lenses. Nikon alone has five lenses in this range in its programme; the 85mm f/1.4, the 85mm f/2, the 105mm f/1.8, the 105mm f/2.5 and the series E lens 100mm f/2.8. To date no AF-lens in the range has been announced by Nikon. These focal lengths are ideal for portraits because even if you arrange for the face to fill the frame, you have enough distance between the camera and the model not to crowd in too much. Faces appear particularly natural with these focal lengths. If you tried to take a portrait full frame with a standard lens, you would have to move very close to your subject and the perspective distortion would be quite apparent. Therefore you would have to move away and then enlarge the required section from your original frame. If you then compared the result with a portrait taken with a 85mm or 105mm tele the latter would be the better picture. If you ask my advice on which of the five Nikon lenses I favour,

The Nikkor 85mm f/2 is a fast portrait telephoto lens. Below the 105mm f/2.5.

then I can only say that the 105mm f/2.5 enjoys a good reputation and is also reasonably priced.

Medium tele lenses – when you cannot move in close
Whenever there is something going on and you are not able to move close to the action it is handy to have a telephoto lens at

149

The medium range telephoto, affordable even in AF construction, the 70-210mm AF zoom f/4.0 (top). The dream of many an amateur photographer is the very excellent Nikkor AF 180mm EF f/2.8 (below).

the ready. The middle range between 135mm and 200mm is particularly useful. Under certain circumstances it is quite an advantage to photograph from a distance. You maintain the overall view of busy scenes and pick out the bit that catches your eye. If you now manage to catch the rider falling off his horse, or a super backhand at tennis, or children at play, you are always "with it" with the telephoto lens.

I would not recommend a 135mm tele. The reason it used to be so popular was that there were not many long telephoto lenses on the market, and those that were cost the earth. This is no longer the case as there is an extensive choice in the

medium range telephoto lenses. A relatively fast and still very handy 180mm telephoto would delight most dedicated amateur photographers and the owner of a F-501 would naturally choose the AF Nikkor f/2.8, 180mm IF, ED.

Long lenses for the hunt: To be quite honest, the very long lenses over 200mm are not really suitable for the amateur photographer. Of course, you could produce very good pictures with such lenses and how to do it has been explained in the chapters on aperture priority, but the really good lenses in

The 300mm f/2.0 in combination with the AF Converter TC-16A - a super-fast "cannon" with a price to match. On the other hand, how about the smaller, lighter and reasonably priced 500mm f/8.0 Nikkor mirror lens?

this category are heavy, very expensive and not very handy. But if you own a baggage mule that coughs up gold as well, why not! Professional sports and animal photographers need such long lenses as part of their basic equipment. The general amateur photographer will have to look for something more reasonably priced. Perhaps you are lucky and can afford the fast AF-Nikkor 300mm f/2.8.

If you want to use one of these long lenses you could look at what is offered by other manufacturers. Or perhaps a fast 135mm, 180mm or 200mm tele together with the AF Converter TC-16A, which increases the focal length by a factor of 1.6 would be the solution. The condition is, of course, that the basic lens has a speed of at least f/2.8.

The Novoflex super fast-action lenses are very popular with sports and animal photographers. They offer a good compromise between optical quality and price. In respect of handling, they can really be considered the fastest. Thanks to a very ingenious pistol-grip mechanism you can keep a moving object in focus and fire quickly at any time. At the moment there is no reasonably priced AF alternative on the market. Mirror lenses are another good option for the general photographer. Part of the optical system consists of mirrors, which result in light, handy and relatively inexpensive constructions. In that case how about the Reflex Nikkor 500mm f/8?

One little warning to avoid disappointment: because of dust, steam, fog, shimmer and various optical inhomogeneities it is not always possible to obtain reasonable quality in shots of far-away subjects, even with a super long tele.

Two zooms and nothing else? Before you go and buy one or two zoom lenses, you should first consider lens speed, handiness, weight and price and compare with the fixed focus lenses. I am sure you will come to the conclusion that fixed focus lenses in the range from 28mm up to 105mm are almost always lighter, faster and even cheaper than a good zoom. The Nikkor 24mm f/2.8 weighs only 250g and measures 4.5cm.

The AF Zoom 35-70mm f/3.3-4.5 must surely be the ideal "standard range zoom", an ideal complement to the 70-210 AF zoom. It is worth considering whether additional fixed focal lengths in the wide-angle or telephoto ranges may be the better solution.

The Nikkor Series E 50mm f/1.8 weighs as little as 155g and measures 2.4cm. The Nikkor Zoom 25-60mm f/4 tips the scales at 600g and is 10.4cm long. As you can see, the fixed focus lenses are one to two stops faster and are much easier to carry. If we look at the longer lenses, for example at a 200mm, then the fixed focus lens is usually faster, but in respect of handling and weight the zoom is equally good.

My advice for the novice is this. Buy the AF standard lens or the AF-Zoom 35-70mm f/3.3-f/4.5 for your F-501. Later, when you know better where your preferences lie, you can complement the standard lens with fixed focal length lenses in the wide-angle range or further AF-zoom lenses. How about a 20mm or a 24mm lens for landscapes, an 85mm or 105mm for portraits, the f/4.0, 70-210mm or the AF fixed focal length 180mm f/2.8 IF, ED for sports photography? No need to buy them all at once. Like many other things in life, photography is an activity that develops with time and experience. Another good bit of advice is that one good lens is preferable to two poor ones.

CRC, IF, ED − Nikon's Sign of Quality

Nikon was among the first manufacturers who managed to

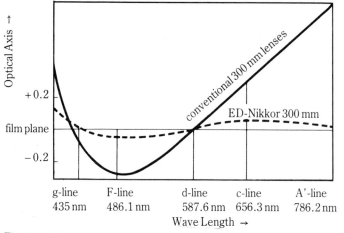

+0.2

film plane

−0.2

conventional 300 mm lenses

ED-Nikkor 300 mm

| g-line | F-line | d-line | c-line | A'-line |
| 435 nm | 486.1 nm | 587.6 nm | 656.3 nm | 786.2 nm |

Wave Length →

The plane of sharpness for different spectral colours, i.e. different wavelengths, does not coincide with the film plane in conventional lenses, the Nikon ED lenses produce an almost perfect result.

Above: Modern Nikon lens with internal focusing. Only a relatively small optical element within the system has to be moved for focusing. Consequently the lens is much slimmer and lighter in construction.

Below: A conventional telephoto lens with heavy helical focusing mount, the entire optical system has to be moved for focusing.

154

optimise their lenses with equal success for both the close and the far ranges. This was a great step forward, because conventional lenses are generally optimized for infinity. This means that any errors are least when the lens focuses on infinity; the reproduction quality is at its optimum. By incorporating so-called close-range correction (CRC) Nikon make some of their lenses suitable for close-range photography. This is achieved by the use of additional movable optical members which compensate to a large extent for certain typical close-range errors such as curvature of field. The CRC lenses incoporate such a design in which an additional group of elements move in relation to the two outer groups. Of course this means additional optical expenditure which make the lens more expensive.

Nikon's achievement in the field of special correction for telephoto lenses is quite exceptional. Chromatic aberration plays a considerable role in long lenses. Blue, green and red light is not combined to a common focal point, which results in colour fringes. These days all modern telephoto lenses are achromatic, that is chromatically corrected to a certain extent, and actual rainbow fringes are quite rare. But this does not constitute real contour sharpness by a long way, only apochromatic lenses can achieve that. The optical precondition for their construction is the use of special types of glass, so-called ED glass, which have extremely low dispersion. They either do not disperse the spectral colours or only in a special way, so that their use in the overall lens construction results in a sum of chromatic aberration of close to zero.

In the matter of focusing Nikon has also been in the forefront. In conventional telephoto lenses the whole groups of lenses move in focusing, which alters the overall length of the lens quite considerably. If you are handling a very long lens this could be quite difficult and cumbersome. If you are pressed for time, you will usually end up with some sort of approximation. Nikon's secret to solve this problem is internal focusing (IF). The overall length of the lens remains constant, and focusing is

achieved by moving the optical member between the two main groups. Not only can you focus more quickly and accurately with these types of lenses, they are also lighter and more convenient. Furthermore, this construction can easily be combined with the automatic correction (CRC) which produces an overall improvement in reproduction quality.

For some years now Nikon has offered a series of lenses which combine all these aspects of technical development. Unfortunately most of them have remained as wishful thinking for the normal amateur photographer as their price is quite forbidding. The AF Nikkor 180mm f/2.8 IF ED has been mentioned previously. This lens combines the sum-total of the art of lens construction at Nikon; with AF-capability and a price still within reasonable bounds.

Are Other Makers' Lenses Another Option?

As far as AF-lenses are concerned there will be no alternative choice for some time for the F-501 user. But if you are considering conventional lenses, then there are a series of manufacturers who offer compatible lenses and it may be a good idea to shop around and to compare prices and quality. What do you say when you want to buy a fisheye lens and you are offered a very good 16mm f/2.8 fisheye with Nikon bayonet that costs only half the amount that Nikon is asking?

Sometimes it is very nearly impossible to ignore the other manufacturers, but good quality is never offered at a give-away price. Beware of being persuaded just by the cheapness of an offer. What point is there in buying a "super zoom" at under £100 and then finding that the pictures are no good? If you have spent the £100 you will find it even more difficult to afford a good one later on.

Nikon of course will only furnish a warranty for their own lenses together with the F-501. That they do not give you any guarantee that other lenses will work perfectly with their own

cameras cannot be held against them. It is possible that other makes may not work very well with your Nikon. The bayonet, the auto-diaphragm release or the flange dimensions could have too much play. Renowned manufacturers hardly ever make such a mistake, and if the manufacturer gives you a six-year guarantee, then your risk is quite minimal.

Does the AF Converter Save Additional Lenses?

The AF converter TC-16A converts old, manual lenses into Af-lenses. The converter acts at the same time as a modest Tele-Converter with a factor of X1.6. This means that the focal length and f/numbers of the lens have to be multiplied by 1.6. The standard 50mm f/1.8, for example, would become an AF 90mm f/2.9 lens when used with the converter. The ordinary standard lens is thus converted into a short telephoto which can be used with full AF facility on the F-501. This works only if the original lens speed is no less than f/2.8. The 200mm f/4 would become a 320mm f/6.4 with the converter, but AF focusing would no longer be possible. The 180mm f/2.8 would just about be suitable for autofocusing and become a 290mm f/4.5. The limit for autofocusing is f/4.5, as you may remember from my previous remarks on the limits of autofocusing.

In practice the use of the AC converter TC 16A could bring some problems with the long focal lengths. Despite a bright subject with sufficient contrast the in-focus indicator in the viewfinder sometimes displays the red warning cross. The explanation is quite simple. When effecting automatic focusing with the converter the motor adjusts a group of lens elements within the converter and not within the lens. Sometimes the setting range within the converter is insufficient to adjust the focus completely. Nikon's advice in these cases is to adjust the lens to infinity, medium range or close-up, depending at what range the subject you are focusing on is positioned, and then try again. Automatic focusing should then function perfectly.

The AF Converter TC-16A adapts a lens with lens speed f/2.8 or faster into an AF-lens. The slight loss in quality is quite acceptable.

You will soon notice that automatic focusing is particularly fast with the AF converter. This is due to the fact that the motor has to adjust only a small group of elements by a small amount, instead of a whole lens by a large amount, as is the case with most AF lenses. The other case of very rapid focusing is with Nikon AF lenses with internal focusing. So if focusing is so fast and convenient with the AF converter, why should you buy AF lenses? Would it not be better to buy a selection of well-tried fast manual Nikkor lenses that are sometimes so conveniently offered at special prices? My own advice is twofold. If you already possess some old Nikkor lenses, or if you come across a very tempting offer, then I would say it would be a good solution to use these lenses with the AF converter. But strictly speaking, the AF converter is only an emergency solution. Nikon will certify that the use of the AF converter TC-16A will not cause any deterioration in picture quality, but this is only relative to other converters. Reading the small print in the manual you will find that the quality in the close range (i.e. sharpness, freedom from distortion, etc.) with the converter is not as good as in the medium and far ranges. Furthermore, the five extra elements, which are used in the construction of the converter, will result in a decline in contrast reproduction and a liability to flare, even though each individual element is multi-coated within the lens

A delightful play with colours captured in a fishing port. Photo: *Wolf Huber*

and the converter. Multicoating will reduce undesired reflections, but it cannot remove them altogether. Make a comparison by taking a picture with the 180mm ED f/2.8 lens, once with and once without, the converter. The result will not be bad with the converter, but without it the colours and outlines are more glowing and crisper. To summarize then, the AF converter is an excellent solution, but it will not replace a good AF lens.

Discover Macro Photography

Whether you photograph coins, stamps, flowers or stones – when taken from very close range, these objects have a very special attraction. No wonder that this type of photography is becoming increasingly popular even with the amateur. But where macro photography begins is a debatable point. I would say at about reproduction scale 1:2. Whatever the subject, it must be well illuminated, focusing must be exact and you must be able to work with a sufficient depth of field. The correct exposure should not present a problem with the F-501 in aperture priority (A) mode or in manual exposure setting. The focus-assist facility could come in useful as well.

Supplementary lenses – the simplest solution: Supplementary lenses are the simplest and cheapest way to enter the field of macro photography. They are screwed into the filter thread of your lens and reduce its focal length, and thereby the nearest focusing distance. For the 52mm filter thread, the usual size of Nikkor lenses, Nikon offers supplementary lenses of +0.7, +1.5 and +3 dioptres. For focal lengths between 85mm and 200mm you should use achromatic supplementary lenses, which Nikon also offers at +1.5 and +2.9 dioptres for the 52mm and 62mm thread

Opinions about graffiti are divided. Is is art? Is it vandalism? In any case, this painted house made a good subject for the photograph. *Photo: Wolf Huber*

The use of extension rings will provide a reproduction ratio of 1:1 with a standard 50mm lens, but at the loss of AF facility.

diameters. If you use the strongest supplementary lens you will achieve a reproduction ratio of 1:3.8 with the 50mm lens, the 105mm lens will produce 1:2.3, and the zoom 35-70mm 1:3.4. If you use supplementary lenses you have to stop down as much as possible to compensate for the decline in reproduction quality, which is inevitable whenever you use supplementary lenses. In any case, the depth of field is quite minimal in macro photography and you will have to stop down for this reason alone. You will be pleased to hear that the autofocusing facility is possible with supplementary lenses. However, it will work only if the lens is set to within the distance range of the macro subject, only then will it be possible to obtain any focusing at all. Or in other words: autofocus with supplementary lenses will work only if you could have focused manually for the same distance to the subject.

Extension rings are not suitable for AF: Extension rings are your next best bet for use with the F-501. Automatic focusing is lost due to the absence of AF motor coupling and AF contacts. Also the lens speed declines quite considerably so that even the AF focus-assist facility no longer functions. Nikon does offer rings with full f/number transfer for

162

extensions of 8mm (PK-11), 14mm (PK-12) and 27.5mm (PK-13). They may be used in any combination and you can produce seven different extensions by using the appropriate rings. If you use all three rings you obtain a reproduction ratio of 1:1 with a 50mm lens. Here too it is recommended that you stop down, as the lenses are corrected to infinity for optimum performance. This means that the reproduction errors are corrected so that they are least at infinity setting. Starting with a reproduction ratio of 1:10 and smaller you have to reckon on an increasing deterioration of the reproduction quality. Exempt from this drawback are of course the Nikon lenses with CRC correction.

Macro lenses – ideal in AF version: The fastest and most reliable equipment for macro photography is doubtless the appropriate macro lenses. By some odd reasoning Nikon has prefixed their Nikkor lenses in this range with "Micro". These

Micro 1:2,8/105 mm

Micro 1:2,8/55 mm

Micro 1:4/200mm IF

Using Micro-Nikkor lenses makes macro photography easy and simple and gives excellent quality.

macro lenses are quite normal lenses, but they are optimized for the close range. The inclusion of floating elements causes the correction to move from infinity to macro range according to the focusing distance. In particular the Micro-Nikkor 50mm f/2.8 should be mentioned here. An excellent lens with which you can continuously focus without extension rings from infinity down to 0.25m (corresponding to 1:2). For the macro fan this would not be a bad choice as a standard lens for his F-501. Two further excellent macro lenses are the Micro-Nikkor 105mm f/2.8 and the 200mm f/4.0. The latter even has internal focusing. Other manufacturers also offer good lenses in the range 80mm to 105mm. Some offer continuous focusing without extension ring up to 1:1. One disadvantage for the longer focal length macro lenses is that they cannot be used with AF function. But this is outweighed by another considerable advantage. The use of long focal lengths is often useful in macro photography. For a reproduction ratio 1:1 the following rule applies:

shooting distance = twice the focal length.

Consequently you have to move as close as 10cm with a 50mm lens, but with a 105mm lens this would be only 21cm and in both cases the reproduction ratio would be 1:1. Because of the greater distance to the subject the danger of causing shadows is much less, and if you are after some small insect you have a better chance to catch it unawares. By the way, you need not worry that the depth of field will decrease if you are using longer lenses in macro photography. For the same reproduction scale the depth of field will be more or less the same for any focal length.

Bellows – for the perfectionist: Bellows form the most universal equipment in macro photography. However, it will take a little time before they are available in the AF system. But this is no real disadvantage; bellows are not the ideal method for the fast shot, but more a tool for the macro fan. A number of

Close-up Equipment

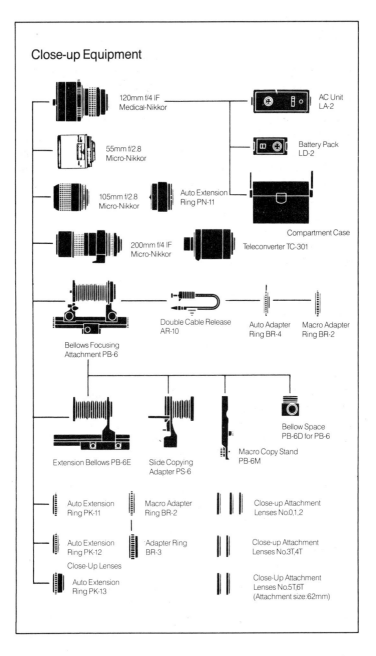

120mm f/4 IF
Medical-Nikkor

AC Unit
LA-2

55mm f/2.8
Micro-Nikkor

Battery Pack
LD-2

105mm f/2.8
Micro-Nikkor

Auto Extension
Ring PN-11

Compartment Case

200mm f/4 IF
Micro-Nikkor

Teleconverter TC-301

Double Cable Release
AR-10

Auto Adapter
Ring BR-4

Macro Adapter
Ring BR-2

Bellows Focusing
Attachment PB-6

Bellow Space
PB-6D for PB-6

Extension Bellows PB-6E

Slide Copying
Adapter PS-6

Macro Copy Stand
PB-6M

Auto Extension
Ring PK-11

Macro Adapter
Ring BR-2

Close-up Attachment
Lenses No.0,1,2

Auto Extension
Ring PK-12

Adapter Ring
BR-3

Close-up Attachment
Lenses No.3T,4T

Close-Up Lenses

Auto Extension
Ring PK-13

Close-Up Attachment
Lenses No.5T,6T
(Attachment size:62mm)

manufacturers (Rowi, Hama, Novoflex and others) offer useful bellows. Together with a good enlarging lens (they are also corrected for close range) you are well on the way to covering everything from flowers to slide duplicating. In addition, focusing rails are obtainable which allow focusing with absolute precision. In the range of 1:1 or over the sharpness is better adjusted by varying the distance to the subject, and not by adjustment to the bellows. Perfectly suitable for all the facilities available in the Nikon system is of course the PB-6 Bellows Focusing Attachment. With great stability, light and precise handling, it makes macro photography a pleasure, and if you wish to take normal subjects with the lens in reverse position, then the bellows are a good tool; all you need is an adapter. The reverse position, where the lens is inserted into the camera with the front element facing the camera, has the advantage that the correction is reversed in favour of the close range. A slide-copying attachment available as an accessory rounds-off the possibilities of this equipment.

Duplicating slides seems much too complicated to many an amateur photographer, but it could be very useful if you are sending valuable slides to the lab for enlargement, or to a photo competition and want to insure against damage or loss. There is also the possibility of improving too bright, too dark or colour cast slides to a certain extent in the duplicating process.

Useful And Not So Useful Accessories

The use of an ever-ready case, such as Nikon offers in great variety is, in my opinion, not really suitable for the photographer. As far as I am concerned such cases are at best a reasonable transport protection when I store my camera in the rucksack or in a travel bag. Whenever I wish to take a picture I always find them inconvenient. If you are thinking of accumulating a comprehensive outfit you could save that money and invest in a really good camera bag. Such a bag should be roomy and offer easy access to the equipment. It should also be light and easy to carry. It should be spray-proof and reasonably dustproof. As you see, we are expecting a lot of such a bag and this cannot be fulfilled by any cheap imitation leather bag.

Aluminium cases give the best protection but they are relatively heavy and cumbersome. Just think when you are going on a leisurely walk about town with such a case, particularly if the name NIKON is printed bright and clear on its side, you will soon have to worry more whether your case is still at your side, rather than concentrating on some lovely sights. The ideal combination is a good, practical camera bag which accommodates everything that you need to carry with you (films, spare batteries, set of lenses) and then a transport case for the rest of the equipment.

Stiff, upright leather cases and lens cases are also of limited use. Usually made of the finest leather they look nice but are only useful for packing your expensive lenses. Did you buy your lenses to keep them safe in a smart case, or did you want to take pictures? If you want to take photographs, you have to have quick access. The best way is to keep your camera, without a case, in the camera bag. However, it is important that the various items carried in the bag do not knock against each other (intermediate compartments). The repeated shocks could loosen the lens fittings.

One item that's absolutely essential, is the camera body cap. This should always be on the camera when no lens is fitted. Apart from protection against dust, it prevents your touching the mirror by mistake when you take the camera out of the bag. Once would be enough and the surface is ruined.

The lens back cap is another essential item. This cap should always be put on as soon as the lens is taken from the camera; not only could you scratch the back element or leave your fingermarks all over it, there is also the danger of bending the aperture lever and other damage. These caps usually fit very badly, even if they are the original Nikon caps, either too loose or hard to fit on. Never pull your lens out of the bag by the back cap, unless you want to make some crash tests.

You can do without a lens cap, provided you always use either a UV-filter or a skylight filter. Both protect the lens against scratches and fingermarks and they cut out harmful UV light. The UV rays could cause blur and fogging, and the skylight filter also removes excessive blue which is rather abundant in cloudy conditions, on the beach, in the mountains or if the sun is high in the sky. Personally I find an excessive blue hue more unacceptable than the warmer rendition of colours that the skylight filter gives me. But this is again a matter of taste, those purists amongst you would probably choose a UV filter.

Another essential item to be fitted on all your lenses is the lens hood, sometimes called a sun-shade. This name is wrong, as the hood is supposed to protect against flare. The image on the film should be formed only by the light that stems from the subject. If light enters the lens from the side it could be reflected in the internal surfaces to create flare and cause poor picture contrast and weak colours. If you take a photograph directly into the sun, then a lens hood would be of little use. In practice lens hoods of hard plastic or metal are better than those made of rubber. The flexible hoods can easily get folded back in the heat of the moment, and then you find you have some inexplicable vignetting on some of your pictures. Flexible hoods are more practical only when you store your camera. In any case, never allow yourself to be persuaded that

lens hoods, UV filter and skylight filter don't belong in the equipment of a real professional.

Filters: A polarising filter is useful against haze and atmospheric reflections. The filter can be rotated because it will allow the light to pass only in certain directions. This is useful if there are strong reflections from water, windows, on gloss paint or plastic surfaces. However, it will not cut-out reflections from metal surfaces. In landscape photography the light is polarized by blue sky at right-angles to the sun. A polarising filter can be used to darken blue sky in this direction without affecting the reproduction of other colours. A polarising filter can be used therefore to filter out the light scattered by the haze and produce a sharper picture with deeper colours. Polarising filters absorb a fair amount of light and you will have to increase the exposure. But this is no problem with the F-501, as the camera will take this into account in all shooting modes. By the way, you don't need the expensive circularly polarising filters with the F-501; the cheaper linear polarization filters will do just as well.

On the matter of creative filters and other attachments, I can only advise you to be cautious. Most of them cannot work as well as the advertisements would have you believe, simply by the laws of physics and optics. One often has to take several exposures with these creative filters and then superimpose them carefully as slides to achieve those picture book effects. One thing you should remember: good pictures are sometimes better with creative filters, but you will never turn a poor picture into a good one by using a creative filter.

Databack MF-19: Databacks enjoy great popularity amongst amateur photographers. Most manufacturers feel obliged to offer them for their better models as an accessory. To be able to expose the date and other relevant data in a series of scientific tests is useful, but for the amateur photographer it may be rather inconvenient. After all, there is plenty of room on the back of the print or the side of the slide frame to scribble

Databack MF-19, useful for recording the progress of experiments, both in the scientific lab or for private investigations. Or if you want to be sure in ten year's time whether this picture had been taken: "when we were in" the databack will expose date and time on the frame.

any information that you wish to record along with the photograph.

The databack for the F-501 is the MF-19. It will allow you to expose the date, time and frame number onto the picture. This is not overdoing it, but there is another facility which can be useful. It is possible to pre-program a self-timer sequence without having to expose any data onto the frame. The camera will then automatically expose at a preset time or at fixed time intervals.

Take care of your camera: The care of your F-501 is quite simple; any excessive cleaning will only damage the camera. Any dust that accumulates in the camera body, for example, from the film transport, has to be removed, otherwise it will adhere to the next film. A dusting brush, or better still a suction brush, is suitable also for dusting the front and rear elements of the lens. If you get a fingermark on your lens it should be removed as soon as possible, because perspiration will attack the lens surface and damage it permanently. Scratches or fingermarks are not directly visible on your photographs, but they will cause them to be noticably flatter, as if a bad soft-focus lens had been used. To clean lenses and filters use a lens cleaning tissue and lens cleaning liquid which is obtainable

specifically for photographic lenses. Always clean them gently, without exerting any pressure, and take care that no dust or hard particles come between the cloth and the lens.

Under no circumstances lubricate your camera or your lenses, not even with the best sewing machine oil, even if you think something sticks. All cameras and lenses are lubricated at the works only at those points where it is necessary, which are usually not accessible to you anyway. If you really think your camera makes unusual noises or that the auto-diaphragm is sluggish, then you will have to send it to an appointed dealer to have it examined.

If you take your camera into environments with a lot of dust, or very high humidity, you will have to keep it in an airtight and watertight plastic case. If it has to be absolutely watertight, let's say you want to take it on a canoe trip, you can get an inflatable bag with float. Don't forget that if your camera is kept in such air-tight conditions, condensation can occur inside and you must not forget to put a container of drying medium, such as silica gel, into the bag.

In winter, when you bring your camera inside after outside photography, the lens will steam up. The only thing you can do is wipe it down and leave it standing in the open until it has dried, and only then should it be stored away.

Apart from this you should follow one golden rule. Don't interfere with the camera or the lenses; they don't take kindly to DIY treatment! Always contact your dealer if there are any defects.

One last piece of advice. If you are not using your camera for some time, remove the batteries. Leaking batteries can damage your camera and four AA or AAA size batteries can do a lot of leaking!

Technical Data of Nikkor and Nikon Series E Lenses

Description	Elements/Lenses	Diagonal Angle of View	Smallest Aperture	Closest Focusing Limit (m)	Filter Diameter (mm)	Weight (g)	Length from Flange (mm)
Wide-angle lenses							
Nikkor 1:5,6/13 mm	12/16	118°	22	0,3	built-in	1200	88,5
Nikkor 1:3,5/15 mm	11/14	110°	22	0,3	4 Special Filters	640	83,5
Nikkor 1:3,5/18 mm	10/11	100°	22	0,25	72	370	61,5
Nikkor 1:3,5/20 mm	8/11	94°	22	0,3	52	240	40,5
Nikkor 1:2/24 mm	10/11	84°	22	0,3	52	300	51,5
Nikkor 1:2,8/24 mm	9/9	84°	22	0,3	52	270	46
Nikkor 1:2/28 mm	8/9	74°	22	0,25	52	340	58,5
Nikkor 1:2,8/28 mm	8/8	74°	22	0,2	52	250	44,5
Nikkor 1:3,5/28 mm	6/6	74°	22	0,3	52	220	46,5
Nikkor 1:1,4/35 mm	7/9	62°	16	0,3	52	390	62
Nikkor 1:2/35 mm	6/8	62°	22	0,3	52	280	51,5
Nikkor 1:2,8/35 mm	6/6	62°	22	0,3	52	230	46
Standard lenses							
Nikkor 1:1,2/50 mm	6/7	46°	16	0,5	52	380	47,5
Nikkor 1:1,4/50 mm	6/7	46°	16	0,45	52	250	40
Nikkor 1:1,8/50 mm	5/6	46°	22	0,45	52	210	37
Telephoto lenses							
Nikkor 1:1,4/85 mm	5/7	28°30'	16	0,85	72	620	64,5
Nikkor 1:2/85 mm	5/5	28°30'	22	0,85	52	315	52,5
Nikkor 1:1,8/105 mm	5/5	23°20'	22	1	62	580	80,5
Nikkor 1:2,5/105 mm	4/5	23°20'	22	1	52	430	69,5
Nikkor 1:2/135 mm	4/6	18°	22	1,3	72	860	93,5
Nikkor 1:2,8/135 mm	4/5	18°	32	1,3	52	430	83,5
Nikkor 1:3,5/135 mm	4/4	18°	32	1,3	52	390	81,5
Nikkor 1:2,8/180 mm ED	5/5	13°40'	32	1,8	72	800	130

	Description	Elements/ Lenses	Diagonal Angle of View	Smallest Aperture	Closest Focusing Limit (m)	Filter Diameter (mm)	Weight (g)	Length from Flange (mm)
	Telephoto lenses							
○	Nikkor 1:4/200 mm	5/5	12° 20'	32	2	52	515	116
●	Nikkor 1:2/200 IF-ED	8/10	12° 20'	22	2.5	122	2300	214
●	Nikkor 1:2.8/300 mm IF-ED	6/8	8° 10'	22	4	39 A	2500	241
○	Nikkor 1:4.5/300 mm	5/6	8° 10'	32	3.5	72	1140	194
○	Nikkor 1:4.5/300 mm IF-ED	6/7	8° 10'	32	2.5	72	990	192
○	Nikkor 1:3.5/400 mm IF-ED	6/8	6° 10'	22	4.5	39 A	2800	296
	Nikkor 1:5.6/400 mm IF-ED	6/7	6° 10'	32	4	72	1200	254
	Nikkor 1:5.6/600 mm IF-ED	6/7	4° 10'	22	5.5	39 A	2700	374
○	Nikkor 1:4/600 mm IF-ED	6/8	4° 10'	22	6.5	39 A	5200	445
	Nikkor 1:8/800 mm IF-ED	7/9	3°	32	10	39 A	3300	452
	Nikkor 1:11/1200 mm IF-ED	9/9	2°	32	14	39 A	3900	569
	Mirror lenses							
	Reflex-Nikkor 1:8/500 mm	3/5	5°	–	4	39	1000	135
	Reflex-Nikkor 1:11/1000 mm	3/5	2° 30'	–	8	39	1900	233.5
	Reflex-Nikkor 1:11/2000 mm	3/5	1° 10'	–	18	built-in	17500	593.5
	Zoom Lenses							
○	Zoom-Nikkor 1:4/25–50 mm	10/11	80°40'–47°50'	22	0.6	72	590	104
○	Zoom-Nikkor 1:3.5/35–70 mm	9/10	62°–34°20'	22	0.35	62	510	96.5
○	Zoom-Nikkor 1:3.5–4.5/35–105 mm	12/16	62°–23°20'	22	0.27	52	510	95
○	Zoom-Nikkor 1:3.5/50–135 mm	13/16	46°–18°	32	0.6	62	700	125
○	Zoom-Nikkor 1:4/80–200 mm	9/13	30°10'–12°20'	32	1.2	62	810	154
●	Zoom-Nikkor 1:2.8/80–200 mm ED	11/15	30°10'–12°20'	32	2.5	95	1900	223
○	Zoom-Nikkor 1:4.5/50–300 mm ED	11/15	46°–18°	32	2.5	95	1800	239
	Zoom-Nikkor 1:8/180–600 mm ED	11/18	13°40'–4°	32	2.5	95	3400	395
	Zoom-Nikkor 1:9.5/200–600 mm	12/19	12°20'–4°	32	4	Series 9	2400	374
	Zoom-Nikkor 1:11/360–1200 mm ED	12/20	6°50'–2°	32	6	122	7100	696

	Description	Elements/Lenses	Diagonal Angle of View	Smallest Aperture	Closest Focusing Limit (m)	Filter Diameter (mm)	Weight (g)	Length from Flange (mm)
	New Zoom Lenses							
○	Zoom-Nikkor 1:3.5/28–55 mm	9/9	74°–46°	22	0.6	52	395	65.5
○	Zoom-Nikkor 1:4/200–400 mm ED	10/15	12°20'–6°10'	32	4	122	3.650	330
	Fisheye Lenses							
●	FE-Nikkor 1:2.8/6 mm	9/12	220°	22	0.25	built-in	5200	159
●	FE-Nikkor 1:2.8/8 mm	8/10	180°	22	0.3	built-in	1100	128
●	FE-Nikkor 1:2.8/16 mm	5/8	180°	22	0.3	4 Filter	330	55.5
	Special lenses							
○	PC-Nikkor 1:3.5/28 mm	8/10	74°	22	0.3	72	380	64.5
○	PC-Nikkor 1:2.8/35 mm	7/8	62°	32	0.3	52	320	61.5
●	Noct-Nikkor 1:1.2/58 mm	6/7	40°50'	16	0.5	52	465	51.5
●	Micro-Nikkor 1:2.8/55 mm	5/6	43°	32	0.25	52	240	62
○	Micro-Nikkor 1:4/105 mm	3/5	23°20'	32	0.47	52	500	96
○	Micro-Nikkor 1:4/200 mm IF	6/9	12°20'	32	0.71	52	740	172
○	Medical-Nikkor 1:4/120 mm IF*	6/9	20°30'	32	0.26	49	920	142
	Nikon Series E							
●	1:2.8/28 mm	5/5	74°	22	0.3	52	155	35
●	1:2.5/35 mm	5/5	62°	22	0.3	52	155	35
●	1:1.8/50 mm	5/6	46°	22	0.6	52	155	27.5
●	1:2.8/100 mm	4/4	24°20'	22	1	52	215	49.5
●	1:2.5/135 mm	4/4	18°	32	1.5	52	395	80.5
○	Zoom 1:3.5/36–72 mm	8/8	62°–33°30'	22	1.2	52	380	63
○	Zoom 1:3.5/75–150 mm	9/12	31°40'–17°	32	1	52	520	117
○	Zoom 1:4/70–210 mm	9/13	34°20'–11°50'	32	0.56	62	760	148

* = Ring flash built-in
A = with special filter holder.

● = suitable for AF Converter
○ = suitable for focus-assist

Index